Live

William Blake

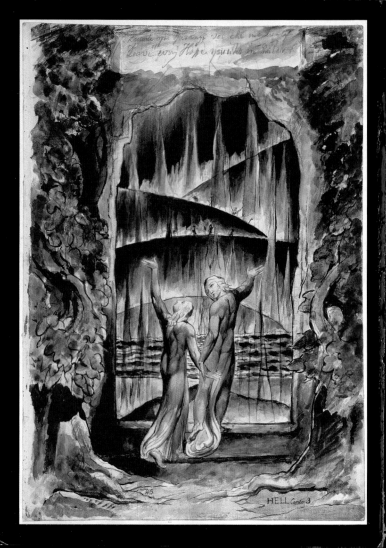

HELL Canto 3

LIVES OF

WILLIAM BLAKE

HENRY CRABB ROBINSON
JOHN THOMAS SMITH
ALEXANDER GILCHRIST

introduced by
MARTIN MYRONE

PALLAS ATHENE

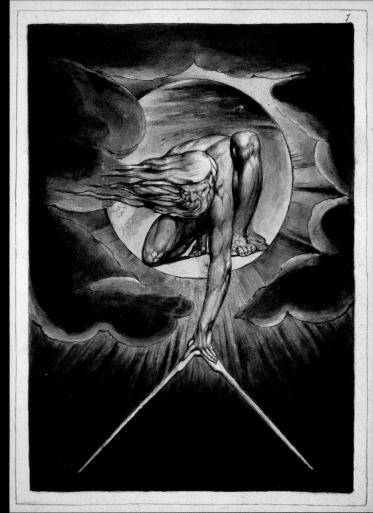

CONTENTS

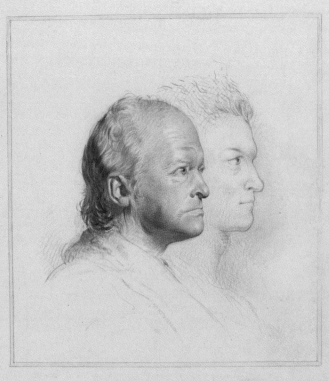

Portraits of

Will^m Blake

at the ages of 28 & 69 years.

INTRODUCTION

MARTIN MYRONE

'A NEW KIND OF MAN, WHOLLY ORIGINAL'

The poet, visionary artist and printmaker William Blake was certainly no fan of the eighteenth-century French philosopher Voltaire, considering him, along with Newton and Gibbon, Hume and Rousseau, as a reprehensible figure pursuing cold and futile thinking: "Mock on! Mock on! tis all in vain! / You throw the sand against the wind / And the wind blows it back again". But it is a famous quotation from Voltaire which might well be adapted as a point of departure for thinking about the biographies and life-stories of Blake which are featured here. What Voltaire quipped of the divine, we might say of Blake: "if he did not exist, it would be necessary to invent him". For Blake, more than almost any other historical figure, is taken as the embodiment of the creative

Opposite: George Richmond after Frederick Tatham, William Blake at the ages of 28 and 69, c. 1830

artist as an ideal type. Among his select admirers during his lifetime, in the decades immediately after his death, and in the generations since the late nineteenth century when his imaginative work was rediscovered, Blake has served as the model of creative authenticity, absolutely committed to his individual vision regardless of his material struggles and critical neglect. For the younger generation of painters and printmakers who provided Blake with spiritual and material sustenance in the last decade of his life, he was, as the seminal modern biographer Alexander Gilchrist observed, '*a new kind of man*, wholly original'.

Gilchrist's biography, the 'Preliminary' of which appears at the end of this collection, proved to be a turning point in the reputation of Blake. First published in 1863, with editorial input from Ann Gilchrist after her husband's death, the biography established a full narrative of Blake's life. Although published more than thirty years after its subject's death, the biographer had been able to consult people who had known the artist late in life. Born in London in 1757, the son of a hosier and haberdasher on the corner of Broad Street, Soho (now Broadwick Street), Blake had trained as an engraver, went to the drawing schools of the Royal Academy, and subsequently surfaced in the 1780s as a painter of literary and imaginative scenes, and at the same time as

an idiosyncratic poet. In the latter guise he appeared in print in 1784, with a collection of *Poetical Sketches* funded by friends and introduced as 'the production of untutored youth' but 'possessed a poetical originality'. Underpinned materially by generally routine work doing commercial engravings for publishers, and by the patronage and support of a few friends, in the 1790s he invented the remarkable technique of 'relief etching', ombining text and images by means which have remained partially obscure and involving colour printed generally much enhanced with ink and watercolours. The books he made by this process, including *Songs of Innocence and of Experience*, *Visions of the Daughters of Albion*, and *America a Prophecy* expressed revolutionary sentiments in matters of politics, society, sexuality and the spirit. Scarcely known and even less understood by his contemporaries, these became even within his lifetime rather rarefied collectors' items, a development which Blake actively helped cultivate with the richer colours and even gilding applied to later printings. He did achieve some celebrity as a designer of more conventional illustrations as well as a reproductive engraver, notably with the designs for an edition of Edward Young's *Night*

Overleaf: Opening from the edition of Young's Night Thoughts *illustrated by Blake; his engravings were probably coloured by others using his models*

But rises in demand for her delay;
She makes a scourge of past prosperity
To sting thee more, and double thy distress.

 LORENZO, fortune makes her court to thee;
Thy fond heart dances, while the syren sings:
Dear is thy welfare; think me not unkind,
I would not damp, but to secure thy joys:
Think not that fear is sacred to the storm;
Stand on thy guard against the smiles of fate.
Is heaven tremendous in its frowns? most sure—
And in its favours formidable too:
* Its favours here are trials, not rewards;
A call to duty, not discharge from care;
And should alarm us, full as much as woes;
Awake us to their cause and consequence;
And make us tremble, weigh'd with our desert.
Awe nature's tumults, and chastise her joys,
Lest, while we clasp, we kill them; nay, invert
To worse than simple misery their charms:
Revolted joys, like foes in civil war,
Like bosom friendships to resentment sour'd,
With rage envenom'd rise against our peace.
Beware what earth calls happiness; beware
All joys, but joys that never can expire:
Who builds on less than an immortal base,
Fond as he seems, condemns his joys to death.

 Mine died with thee, PHILANDER! thy last sigh
Dissolved the charm; the disenchanted earth
Lost all her lustre: where her glitt'ring towers?
Her golden mountains where?—all darken'd down

To naked waste ; a dreary vale of tears :
The great magician's dead ! thou poor pale piece
Of outcast earth—in darkness ! what a change
From yesterday ! thy darling hope so near,
Long-labour'd prize, O how ambition flush'd
Thy glowing cheek ! ambition, truly great,
Of virtuous praise : death's subtle seed within,
Sly, treacherous miner ! working in the dark,
Smiled at thy well-concerted scheme, and beckon'd
The worm to riot on that rose so red,
Unfaded ere it fell—one moment's prey !
 Man's foresight is conditionally wise ;
Lorenzo ! wisdom into folly turns
Oft, the first instant its idea fair
To lab'ring thought is born : how dim our eye !
* The present moment terminates our sight ;
Clouds, thick as those on doomsday, drown the next ;
We penetrate, we prophesy in vain :
Time is dealt out by particles ; and each,
Ere mingled with the streaming sands of life,
By fate's inviolable oath is sworn
Deep silence, " where eternity begins."
 By nature's law, what may be, may be now ;
There's no prerogative in human hours :
In human hearts what bolder thought can rise,
Than man's presumption on to-morrow's dawn ?
Where is to-morrow ?—in another world !
For numbers this is certain ; the reverse
Is sure to none ; and yet on this perhaps,
This peradventure—infamous for lies,

Thoughts in 1797 and for Robert Blair's poem *The Grave* in 1808, done for the publisher Robert Cromek. As an obituarist in *The Literary Gazette* noted, 'Few persons of taste are unacquainted with the designs by Blake' which had attracted the 'warmest praises of all our prominent artists'. But Blake otherwise struggled to achieve much general recognition. In 1806 an affectionate biographical notice of Blake had appeared in *A Father's Memoirs of His Child* by the scholar Benjamin Heath Malkin (with whom Blake shared a number of social contacts); this had also, importantly, included a sampling of Blake's lyrical poems, including the perennial favourite, 'The Tyger'. But a disastrous one-man show in 1809 helped precipitate his withdrawal from public life. It was only after meeting John Linnell in 1818, then Samuel Palmer and John Varley, and the direct patronage and business skills they brought to bear on the older artist's life, which sustained Blake and his wife. He completed his last, most extensive 'prophetic book', *Jerusalem*, and undertook his most ambitious and personal painting and engraving projects, including a series of watercolours illustrating Dante's *Divine Comedy* which occupied him until within days of his death in August 1827.

The notion of Blake as a '*new kind of man*' positions

Opposite: Plate 25 from Jerusalem The Emanation of the Giant Albion, *1804–c. 1820, printed 1821*

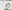

And there was heard a great lamenting in Beulah: all the Regions
Of Beulah were moved as the tender bowels are moved: & they said:

Why did you take Vengeance O ye Sons of the mighty Albion?
Planting these Oaken Groves: Erecting these Dragon Temples
Injury the Lord heals, but Vengeance cannot be healed:
As the Sons of Albion have done to Luvah: so they have in him
Done to the Divine Lord & Saviour: who suffers with those that suffer:
For not one sparrow can suffer, & the whole Universe not suffer also,
In all its Regions, & its Father & Saviour not pity and weep.
But Vengeance is the destroyer of Grace & Repentance in the bosom
Of the Injurer: in which the Divine Lamb is cruelly slain:
Descend O Lamb of God & take away the imputation of Sin
By the Creation of States & the deliverance of Individuals Evermore Amen.

Thus wept they in Beulah over the Four Regions of Albion
But many doubted & despair'd & imputed Sin & Righteousness
To Individuals & not to States, and these Slept in Ulro.

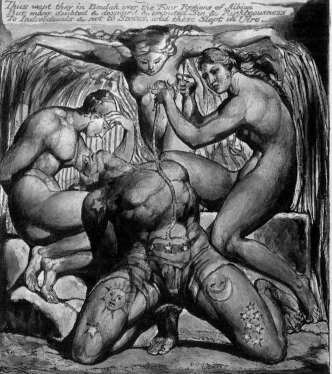

him as an historical novelty, and moots the possibility he represented now just a different sort of artist but a new kind of human being. At first glance this might seem to run contrary to Blake's vision of his own art. He was 'out of joint' with the times, and knowingly so. He appealed to the model of the Gothic artists, located historically in the middle ages but also outside of history altogether, and claimed he was following visions of monumental works of 'Persian, Hindoo, and Egyptian Antiquity. He took a combative stance towards the prevailing values of modern-day artistic production. in the art of his training, engraving, he reviled the delicate finesse of much contemporary printmaking. He was trained by James Basire who was in many regards an old-fashioned figure, part of a dynasty of engravers who maintained a successful business over several generations, with Blake's master being particularly notable for his prints of antiquarian and scientific subject matter executed in a rigorous line-engraving manner. As for painting, Blake commented at some length and with great liveliness on what he perceived to be the horrors of contemporary oil-painting: seductive, deceptive, corrupting oil painting. His own paintings, in watercolour and in tempera, he designated as 'fresco', the term he deployed also in describing his

Opposite: Adam naming the beasts, 1810. Possibly an idealised self-portrait

colour prints. It is telling that the circle of Blake's followers centred on Samuel Palmer and including George Richmond and Edward Calvert, termed themselves 'The Ancients'. The old world of the medieval workshop and early renaissance print studio represented to them a more authentic context for art production than was to be found in the present day, with its art academies, galleries and dealers, and in their view this anachronistic possibility had been renewed in modern times by Blake more effectively than anyone else.

But, as the literary historians Michael Löwy and Robert Sayre brought to our attention, such posturing against the modern world is a characteristic gesture *of* modern times. Blake was in that regard a peculiarly modern figure, and his appeal to successive generations of self-consciously progressive artists and poets, musicians and radicals, begins to make more sense when we understand that. If their attention has kept the memory of Blake alive, and helped ensure that his poetry and art has been preserved and made increasingly accessible to the wide public, there have been losses as well as gains.

Surveying the early biographical accounts included here, we certainly encounter the originals of the favourite myths and ideals of Blake the inspired artist and poet. But we may be struck, too, of some less familiar aspects, and of how comparatively careful these earlier writers

were in assessing Blake's background and circumstances. Characterizing his subject's upbringing, Gilchrist made a point of saying that the Broad Street of the late 1700s was quite a different place to the street known by then as the source of an infamous cholera outbreak of 1854. It was 'highly respectable, not as it appeared now, 'dirty, forlorn-looking'. A manuscript account by the sculptor and friend of Blake, Frederick Tatham, had already noted that his father was 'a hosier of respectable trade and easy habits, and seems to have been a man well-to-do'. While later commentators have taken Blake's later, embittered words of contempt for the Royal Academy at face value, another friend, Benjamin Malkin stated 'Here he drew with great care, perhaps all, or certainly nearly all the noble antique figures in various views' and 'he drew a great deal from life, both at the academy and at home'. The journalist Henry Crabb Robinson and the obituarists emphasise his eccentricities and unworldliness, and there are comments throughout which throw doubt on his technical abilities as an artist. The observations made about Blake by Robinson, recorded in his diary (1811-67) and published Reminiscences (1852) have been especially influential. From a dissenting background, Robinson

Overleaf: Nebuchadnezzar, 1795, this copy printed c. 1805. One of the twelve highly ambitious large colour prints produced by Blake in a single year

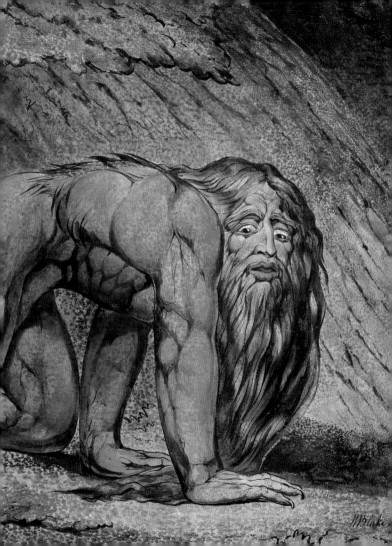

had been barred from pursuing a university education in England, and had trained instead as a lawyer. In receipt of a modest legacy, Robinson ended up travelling on the continent and secured his university education in Germany. His journalistic writings provided a vital link between German and English literary cultures at this juncture, in both of which he was well-connected. This was the context for his article 'Künstler, Dichter, und Religiöser Schwämer' (Artist, Poet and Religious Mystic) in 1811, the first extended critical essay to be published on Blake (reproduced here in full for the first time in English). The biographical information provided by Robinson incorporated and slightly expanded that given in Malkin's earlier account. But what was really crucial was the overall characterisation of the artist, backed up with lots of direct quotations from Blake's works and directed towards a literary readership. Robinson's later assessment: 'Shall I call Blake artist, genius, mystic or madman? Probably he is all' encapsulates his modern reputation, while keeping in play those contraries which are too often swept aside by the modern presumption that Blake is undoubtedly a genius above all, and that the imputations either that he is an artist in a regular sense or a 'madman' are simply wrong-headed.

These early biographies are more revealing than many modern art-historical accounts with regards to the

circumstances in which Blake embarked upon his vocation as an artist. He might reasonably have been expected to enter the family trade. But his long-standing friend the artist and curator John Thomas Smith relates that it was not inner vision but being 'destitute of the dexterity of a London shopman' that sent him away from 'the counter as a booby'. Smith is alluding to an essay by Samuel Johnson from *The Rambler* (27 April 1751), narrating the story of a landowner's younger son sent to the city to learn the trade of haberdashery, 'to handle a yard with great dexterity, to wind tape neatly upon the ends of my fingers, and to make up parcels with exact frugality of paper and packthread'. Although this is not Smith's point, the allusion does helpfully remind us of how such a commercial life was not isolated from genteel society. Blake's family were in a business which served the upper end of the social scale, and it was run in such a manner as to provide a degree of security. Indeed the firm traded for sixty years; from 1752, when James Blake the artist's father took it on from his father-in-law, to 1812, when the younger James Blake, Blake's brother, finally left Broad Street: sixty years which saw three global wars, economic decline and depression, punishing new tax regimes, and innumerable bankruptcies and failed businesses. The Blakes may not have been affluent, but they were not so precariously positioned. Smith too emphasizes the role

of friends, including the sculptor John Flaxman and the Rev. Mathews (who funded the *Poetical Sketches*), the fellow Academy student Thomas Stothard, and especially the role played by Catherine, whom Blake had married in 1782. Blake, he tells us, 'allowed her, till the last moment of his practice, to take off his proof impressions and print his works'. His 'visionary imaginations' are not so much outlandish, as a result of the power of his mind, 'disuniting all other thoughts ... by this abstracting power, that the objects of his compositions were before him in his mind's eye, that he frequently believed them to be speaking to him'. They had, in other words, an internal source in the form of an overheating imagination. And as 'Limited as Blake was in his pecuniary circumstances', his widow 'survives him clear of even a sixpenny debt', a circumstance which was an increasing rarity. A slightly later biographer, Allan Cunningham, also insisted that Blake earned a decent crust: 'The day was given to the graver, by which he earned enough to maintain himself respectably; and he bestowed his evenings upon painting and poetry'. Blake's material struggles and creative frustration was in Cunningham's account a matter self-delusion: 'He thought that he had but to sing songs and draw designs, and become great and famous'.

Besides such comparatively pragmatic observations about Blake's circumstances, one important thing which

F. J. Shields,
'Blake's work-room
and death-room in
Fountain Court',
1880

is striking about these accounts is their dates of composition. If there is no doubt that Blake was, to use his own term, 'hid' from the world, profoundly so for periods of his life, especially c. 1812-1818, it is the case that some detail of his life and character could have been known to English and German literary readers even before that date. He was sufficiently well-known to receive obituary notices in mainstream journals. And then, in 1828 and 1831, there were the biographical chapters by Smith and Cunningham (mostly based on Smith), respectively, both much read in the nineteenth century and beyond.

Confronting the already-rampant mythology of Blake's isolation and poverty, Tatham had noted: 'Some persons may say, Had poor Blake ever in his whole life £60 worth of plate to lose? Had poor half-starved Blake ever a suit of clothes beyond the tatters on his back? Yes!!!

he enjoyed in the early part of his life not only comforts but necessaries'. But such observations have been rather obscured in modern scholarship, so that the meticulous work of G. E. Bentley summarized in his final book on Blake, *William Blake in the Desolate Market*, came as something of a surprise. This showed Blake had, indeed, been able to 'maintain himself respectably' by commercial engraving over the years, as well as smaller sums from selling his paintings and illuminated books. While never wealthy, and certainly struggling (like many other people) in the tough years that followed Waterloo, Blake was not ever quite so desperate as had been imagined. The stories of Blake naked up a tree, of experimental sexual practices, of outrageous political opinion, with the artist openly sporting a *bonnet rouge* in the street, similarly belong to a later age. Blake the Cockney visionary, wild-eyed Soho eccentric, some sort of urchin or underdog who had pulled himself up from the gutter, is a modern fabrication, crafted to match our complacent myths of creative self-fulfillment and social mobility.

So it is that Voltaire's quip has application here. Blake has been 'invented' for the modern age. But the point of Voltaire's quote is that such an invention is not pure, willful fabrication. It answered a need, in the case of Blake, not for the divine as such, but of an authentic spirit of the artist which might in turn assume a certain

divinity. In one of her novels, the society diarist Lady Charlotte Bury articulated what was only beginning to take shape in the years after Blake's death as an idea of the Bohemian artist, the perverse cultural logic which dictated that 'Persons ... living in a garret and in an abject poverty, enjoyed the brightest visions, the brightest pleasures, the most pure and exalted piety'. The point surely needs to be made that such authenticity seemed increasingly perilous, even within Blake's lifetime, and certainly with the onslaught of the industrialization of culture in the Victorian era. Knowing their subject personally, or through friends and family, these early biographers were more able to reconcile Blake's errant imaginative powers with the practical realities of his life and contemporary reputation. Later commentators saw the situation in rather starker, more emphatically contrary terms. The Blake who had friends and supporters, who had a certain reputation, who made a modest living, fell to one side in favour of the mythicized Blake, the outrageous sexual radical, the oppressed outsider, the working-class hero, Cockney visionary. These myths are unlikely to go away, least of all in the face of factual evidence or reasoned argument. But there is some work to be done by doing nothing more radical than going back to these, the earliest life-stories of Blake, and reading them afresh, looking in them not just for the seeds of the

invented Blake we favour, but also the historical Blake who may be more complex and less familiar.

Some further reading

G.E. Bentley, Jr,
Blake Records: Documents (1714–1841) Concerning the Life of William Blake (1757–1827) and his Family,
London and New Haven 2004

G.E. Bentley, Jr,
William Blake in the Desolate Market,
Montreal 2014

Shirley Dent and Jason Whittaker,
Radical Blake: Influence and Afterlife from 1827,
London 2002

Morris Eaves, 'On Blakes We Want and Blakes We Don't',
Huntington Library Quarterly, 58:3/4 (1995), pp. 413–39

Michael Löwry and Robert Sayre,
Romanticism Against the Tide of Modernity, trans. Catherine Porter,
Durham NC and London 2001

Colin Trodd,
Visions of Blake: William Blake in the Art World 1830–1930,
Liverpool 2012

William Vaughan,
Samuel Palmer: Shadows on the Wall,
New Haven and London 2015

Joseph Anthony Wittreich, Jr,
Nineteenth Century Accounts of William Blake,
Gainesville 1970

HENRY CRABB ROBINSON

Reminiscences of Blake

1809-1827

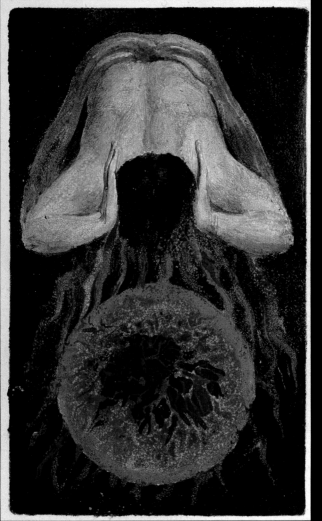

It was at the latter end of the year 1825 that I put in writing my recollections of this most remarkable man. The larger portions are under the date of the 18th of December. He died in the year 1827. I have therefore now revised what I wrote on the 10th of December and afterwards, and without any attempt to reduce to order, or make consistent the wild and strange rhapsodies uttered by this insane man of genius, thinking it better to put down what I find as it occurs, though I am aware of the objection that may justly be made to the recording the ravings of insanity in which it may be said there can be found no principle, as there is no ascertainable law of mental association which is obeyed; and from which therefore nothing can be learned.

This would be perfectly true of *mere* madness—but does not apply to that form of insanity ordinarily called monomania, and may be disregarded in a case like the present in which the subject of the remark was unquestionably what a German would call a *Verunglückter Genie*, whose theosophic dreams bear a close resemblance to those of *Swedenborg*—whose genius as an artist was praised by no less men than *Flaxman* and *Fuseli*—and whose poems were thought

Opposite: Plate 17 from The First Book of Urizen, *1794*

worthy republication by the biographer of *Sweden-borg* (*Wilkinson*), and of which Wordsworth said after reading a number—they were the 'Songs of Innocence and Experience showing the two opposite sides of the human soul'—'There is no doubt this poor man was mad, but there is something in the madness of this man which interests me more than the sanity of Lord Byron and Walter Scott!' The German painter *Götzenberger* (a man indeed who ought not to be named *after the others* as an authority for my writing about Blake) said, on his returning to Germany about the time at which I am now arrived, 'I saw in England many men of talents, but only three men of genius, Coleridge, Flaxman, and Blake, and of these Blake was the greatest.' I do not mean to intimate my assent to this opinion, nor to do more than supply such materials as my intercourse with him furnish to an uncritical narative to which I shall confine myself. I have written a few sentences in these reminiscences already, those of the year 1810. I had not then begun the regular journal which I afterwards kept. I will therefore go over the ground again and introduce these recollections of 1825 by a reference to the slight knowledge I had of him before, and what occasioned my taking an interest in him, not caring to repeat what Cunningham has recorded of him in the volume

of his *Lives of the British Painters*, etc. etc., except thus much. It appears that he was born

[The page ends here.]

Dr. Malkin, our Bury Grammar School Headmaster, published in the year 1806 a Memoir of a very precocious child who died . . . years old, and he prefixed to the Memoir an account of Blake, and in the volume he gave an account of Blake as a painter and poet, and printed some specimens of his poems, viz. 'The Tyger,' and ballads and mystical lyrical poems, all of a wild character, and M. gave an account of Visions which Blake related to his acquaintance. I knew that Flaxman thought highly of him, and though he did not venture to extol him as a genuine seer, yet he did not join in the ordinary derision of him as a madman. Without having seen him, yet I had already conceived a high opinion of him, and thought he would furnish matter for a paper interesting to Germans, and therefore when *Fred. Perthes*, the patriotic publisher at Hamburg, wrote to me in 1810 requesting me to give him an article for his Patriotische Annalen, I thought I could do no better than send him a paper on Blake, which was translated into German by *Dr. Julius*, filling, with a few small poems copied and translated, 24 pages. These appeared in the first and last No. of volume

2 of the Annals. The high-minded editor boldly de-
clared that as the Emperor of France had annexed
Hamburg to France he had no longer a country, and
there could no longer be any patriotical Annals ! ! !
Perthes' Life has been written since, which I have not
seen. I am told there is in it a civil mention of me.
This *Dr. Julius* introduced himself to me as such trans-
lator a few years ago. He travelled as an Inspector of
Prisons for the Prussian Government into the United
States of America. In order to enable me to write this
paper, which, by the bye, has nothing in it of the least
value, I went to see an exhibition of Blake's original
paintings in Carnaby Market, at a hosier's, Blake's
brother. These paintings filled several rooms of an or-
dinary dwelling-house, and for the sight a half-crown
was demanded of the visitor, for which he had a cata-
logue. This catalogue I possess, and it is a very curious
exposure of the state of the artist's mind. I wished to
send it to Germany and to give a copy to Lamb and
others, so I took four, and giving 10s., bargained that
I should be at liberty to go again. 'Free! as long as
you live,' said the brother, astonished at such a lib-
erality, which he had never experienced before, nor
I dare say did afterwards. *Lamb* was delighted with
the catalogue, especially with the description of a
painting afterwards engraved, and connected with

which is an anecdote that, unexplained, would reflect discredit on a most amiable and excellent man, but which Flaxman considered to have been not the wilful act of *Stodart*. It was after the friends of Blake had circulated a subscription paper for an engraving of his *Canterbury Pilgrims*, that *Stodart* was made a party to an engraving of a painting of the same subject by himself. Stodart's work is well known, Blake's is known by very few. Lamb preferred it greatly to Stodart's, and declared that Blake's description was the finest criticism he had ever read of Chaucer's poem.

In this catalogue Blake writes of himself in the most outrageous language—says, 'This artist defies all competition in colouring'—that none can beat him, for none can beat the Holy Ghost—that he and Raphael and Michael Angelo were under divine influence—while Corregio and Titian worshipped a lascivious and therefore cruel deity—Rubens a proud devil, etc. etc. He declared, speaking of colour, Titian's men to be of leather and his women of chalk, and ascribed his own perfection in colouring to the advantage he enjoyed in seeing daily the primitive men walking in their native nakedness in the mountains of Wales. There were about thirty oil-paintings, the colouring excessively dark and high, the veins black, and the colour of the primitive men very like

that of the Red Indians. In his estimation they would probably be the primitive men. Many of his designs were unconscious imitations. This appears also in his published works—the designs of *Blair's Grave*, which Fuseli and Schiavonetti highly extolled—and in his designs to illustrate *Job*, published after his death for the benefit of his widow.

To this catalogue and in the printed poems, the small pamphlet which appeared in 1783, the edition put forth by Wilkinson of 'The Songs of Innocence,' and other works already mentioned, to which I have to add the first four books of Young's *Night Thoughts*, and Allan Cunningham's *Life* of him, I now refer, and will confine myself to the memorandums I took of his conversation. I had heard of him from Flaxman, and for the first time dined in his company at the Aders'. *Linnell* the painter also was there—an artist of considerable talent, and who professed to take a deep

Opposite: Satan calling up his Legions, c. 1809. Exhibited by Blake in 1809, and described by him as 'a composition for a more perfect painting, afterwards executed for a Lady of high rank' (the Countess of Egremont). It later belonged to Samuel Palmer

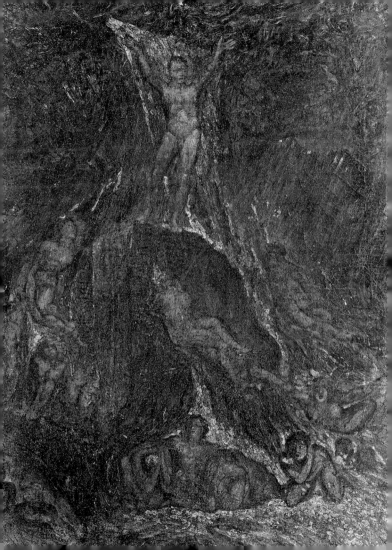

interest in Blake and his work, whether of a perfectly disinterested character may be doubtful, as will appear hereafter. This was on the 10th of December.

I was aware of his idiosyncracies and therefore to a great degree prepared for the sort of conversation which took place at and after dinner, an altogether unmethodical rhapsody on art, poetry, and religion—he saying the most strange things in the most unemphatic manner, speaking of his *Visions* as any man would of the most ordinary occurrence. He was then 68 years of age. He had a broad, pale face, a large full eye with a benignant expression—at the same time a look of languor, except when excited, and then he had an air of inspiration. But not such as without a previous acquaintance with him, or attending to *what* he said, would suggest the notion that he was insane. There was nothing *wild* about his look, and though very ready to be drawn out to the assertion of his favourite ideas, yet with no warmth as if he wanted to make proselytes. Indeed one of the peculiar features of his scheme, as far as it was consistent, was indifference and a very extraordinary degree of tolerance and satisfaction with what had taken place. A

Opposite: The Man who Taught Blake Painting in his Dreams, replica, perhaps by John Linnell, of drawing made 1819-20

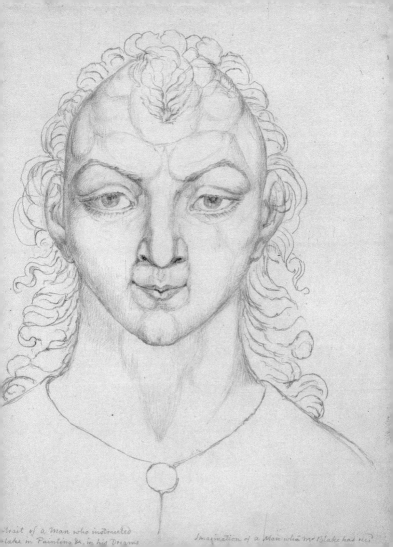

Portrait of a Man who instructed
Mr Blake in Painting &c. in his Dreams Imagination of a Man who Mr Blake has see

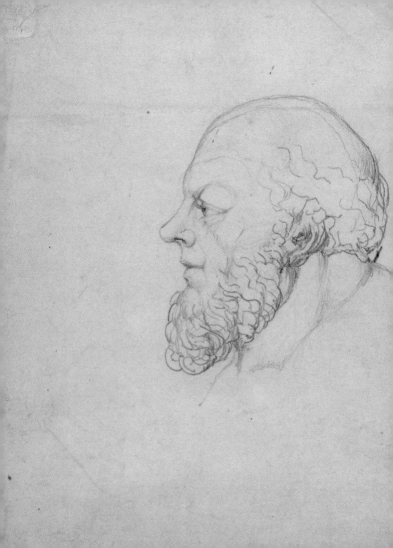

sort of pious and humble optimism, not the scornful optimism of Candide. But at the same time that he was very ready to praise he seemed incapable of envy, as he was of discontent. He warmly praised some composition of Mrs. Aders, and having brought for Aders an engraving of his Canterbury Pilgrims, he remarked that one of the figures resembled a figure in one of the works then in Aders's room, so that he had been accused of having stolen from it. But he added that he had drawn the figure in question 20 years before he had seen the *original* picture. However, there is 'no wonder in the resemblance, as in my youth I was always studying that class of painting.' I have forgotten what it was, but his taste was in close conformity with the old German school.

This was somewhat at variance with what he said both this day and afterwards—implying that he copies his Visions. And it was on this first day that, in answer to a question from me, he said, '*The Spirits told me.*' This lead me to say: Socrates used pretty much the same language. He spoke of his Genius. Now, what affinity or resemblance do you suppose was there between the *Genius* which inspired Socrates and your *Spirits*? He smiled, and for once it seemed to me as if he had

Opposite: Visionary head of Socrates, c. 1820

a feeling of vanity gratified. 'The same as in our coun-
tenances.' He paused and said, 'I was Socrates'—and
then as if he had gone too far in that—'or a sort of
brother. I must have had conversations with him. So I
had with Jesus Christ. I have an obscure recollection
of having been with both of them.' As I had for many
years been familiar with the idea that an eternity *a
parte post* was inconceivable without an eternity *a parte
ante*, I was naturally led to express that thought on this
occasion. His eye brightened on my saying this. He
eagerly assented: 'To be sure. We are all coexistent
with God; members of the Divine body, and partak-
ers of the Divine nature.' Blake's having adopted this
Platonic idea led me on our *tête-à-tête* walk home at
night to put the popular question to him, concerning
the imputed Divinity of Jesus Christ. He answered:
'He is the only God'—but then he added—'And so
am I and so are you.' He had before said—and that
led me to put the question—that Christ ought not to
have suffered himself to be crucified.' 'He should not
have attacked the Government. He had no business
with such matters.' On my representing this to be in-
consistent with the sanctity of divine qualities, he said
Christ was not yet become the Father. It is hard on

Opposite: page from There is no natural religion, *1788 (printed 1794)*

Therefore
God becomes as
we are, that we
may be as he
is

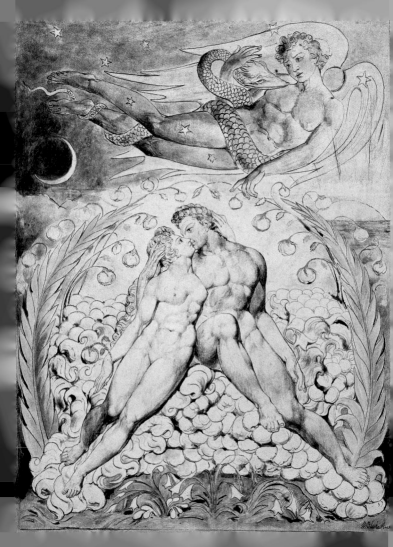

bringing together these fragmentary recollections to fix Blake's position in relation to Christianity, Platonism, and Spinozism.

It is one of the subtle remarks of *Hume* on the tendency of certain religious notions to reconcile us to whatever occurs, as God's will. And apply this to something Blake said, and drawing the inference that there is no use in education, he hastily rejoined: 'There *is* no use in education. I hold it wrong. It is the great Sin. It is eating of the tree of knowledge of Good and Evil. That was the fault of Plato: he knew of nothing but the Virtues and Vices. There is nothing in all that. Everything is good in God's eyes.' On my asking whether there is nothing absolutely evil in what man does, he answered: 'I am no judge of that—perhaps not in God's eyes.' Notwithstanding this, he, however, at the same time spoke of error as being in heaven; for on my asking whether Dante was pure in writing his *Vision*, 'Pure,' said Blake. 'Is there any purity in God's eyes? No."He chargeth his angels with folly."' He even extended this liability to error to the Supreme Being. 'Did he not repent him that he had made Nineveh?' My journal here has the remark

Opposite: Satan watching the endearments of Adam and Eve, from Blake's illustrations to Milton's Paradise Lost, *in the set begun for John Linnell in c. 1822, reusing images made in 1808*

that it is easier to retail his personal remarks than to reconcile those which seemed to be in conformity with the most opposed abstract systems. He spoke with seeming complacency of his own life in connection with Art. In becoming an artist he 'acted by command.' The Spirits said to him, 'Blake, be an artist.' His eye glistened while he spoke of the joy of devoting himself to *divine art* alone. 'Art is inspiration. When Mich. Angelo or Raphael, in their day, or Mr. Flaxman, does any of his fine things, he does them in the Spirit.' Of fame he said: 'I should be sorry if I had any earthly fame, for whatever natural glory a man has is so much detracted from his spiritual glory. I wish to do nothing for profit. I want nothing—I am quite happy.' This was confirmed to me on my subsequent interviews with him. His distinction between the Natural and Spiritual worlds was very confused. Incidentally, Swedenborg was mentioned—he declared him to be a Divine Teacher. He had done, and would do, much good. Yet he did wrong in endeavouring to explain to the *reason* what it could not comprehend. He seemed to consider, but that was not clear, the visions of Swedenborg and Dante as of the same kind. Dante was the greater poet. He too was wrong in occupying his mind about political objects. Yet this did not appear to affect his estimation of Dante's genius, or his opinion

of the truth of Dante's visions. Indeed, when he even declared Dante to be an Atheist, it was accompanied by expression of the highest admiration; though, said he, Dante saw Devils where I saw none.

I put down in my journal the following insulated remarks. *Jacob Böhmen* was placed among the divinely inspired men. He praised also the designs to Law's translation of Böhmen. Michael Angelo could not have surpassed them.

'*Bacon, Locke*, and *Newton* are the three great teachers of Atheism, or Satan's Doctrine,' he asserted.

'*Irving* is a highly gifted man—he is a *sent* man; but they who are sent sometimes go further than they ought.

Calvin. I saw nothing but good in Calvin's house. In *Luther's* there were *Harlots*. He declared his opinion that the earth is flat, not round, and just as I had objected the circumnavigation dinner was announced. But objections were seldom of any use. The wildest of his assertions was made with the veriest indifference of tone, as if altogether insignificant. It respected the natural and spiritual worlds. By way of example of the difference between them, he said, '*You* never saw the spiritual Sun. I have. I saw him on Primrose Hill.'

Overleaf: Newton, 1795-c. 1805

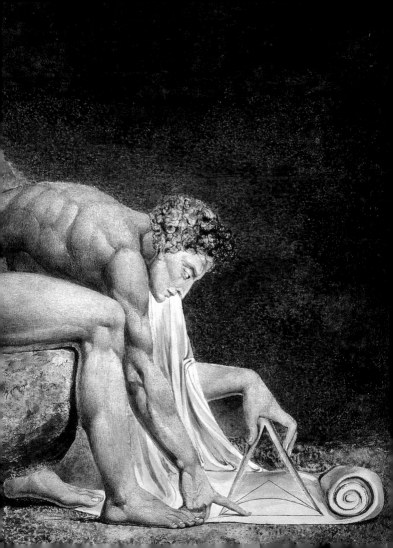

He said, 'Do you take me for the Greek Apollo?' 'No!' I said. '*That* (pointing to the sky) that is the Greek Apollo, He is Satan.'

Not everything was thus absurd. There were glimpses and flashes of truth and beauty: as when he compared moral with physical evil. 'Who shall say what God thinks evil? That is a wise tale of the Mahometans—of the Angel of the Lord who murdered the Infant.'—The Hermit of Parnell, I suppose. 'Is not every infant that dies of a natural death in reality slain by an Angel?'

And when he joined to the assurance of his happiness, that of his having suffered, and that it was necessary, he added, 'There is suffering in Heaven; for where there is the capacity of enjoyment, there is the capacity of pain.

I include among the glimpses of truth this assertion, 'I know what is true by internal conviction. A doctrine is stated. My heart tells me It *must* be true.' I remarked, in confirmation of it, that, to an unlearned man, what are called the *external* evidences of religion

Opposite: Albion Rose. Blake worked on this image from around 1780; this version is from the Large Book of Designs *made for Ozias Humphry in 1796. On a later one he added the inscription 'Albion rose from where he laboured at the Mill with Slaves / Giving himself for the Nations he danc'd the dance of Eternal Death'.*

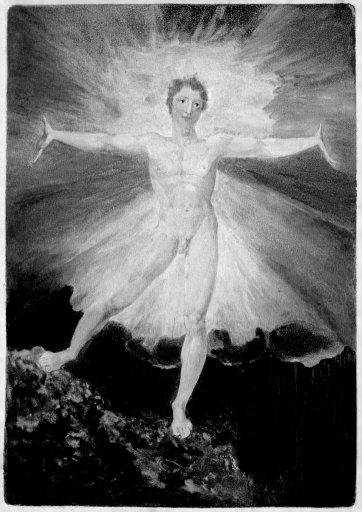

can carry no conviction with them; and this he assented to.

After my first evening with him at Aders's, I made the remark in my journal, that his observations, apart from his Visions and references to the spiritual world, were sensible and acute. In the sweetness of his countenance and gentility of his manner he added an indescribable grace to his conversation. I added my regret, which I must now repeat, at my inability to give more than incoherent thoughts. Not altogether my fault perhaps.

On the 17th I called on him in his house in Fountain's Court in the Strand. The interview was a short one, and what I saw was more remarkable than what I heard. He was at work engraving in a small bedroom, light, and looking out on a mean yard. Everything in the room squalid and indicating poverty, except himself. And there was a natural gentility about him, and an insensibility to the seeming poverty, which quite removed the impression. Besides, his linen was clean, his hand white, and his air quite unembarrassed when he begged me to sit down as if he were in a palace. There was but one chair in the room besides that on

which he sat. On my putting my hand to it, I found that it would have fallen to pieces if I had lifted it, so, as if I had been a Sybarite, I said with a smile, 'Will you let me indulge myself?' and I sat on the bed, and near him, and during my short stay there was nothing in him that betrayed that he was aware of what to other persons might have been even offensive, not in his person, but in all about him.

His wife I saw at this time, and she seemed to be the very woman to make him happy. She had been formed by him. Indeed, otherwise, she could not have lived with him. Notwithstanding her dress, which was poor and dirty, she had a good expression in her countenance, and, with a dark eye, had remains of beauty in her youth. She had that virtue of virtues in a wife, an implicit reverence of her husband. It is quite certain that she believed in all his visions. And on one occasion, not this day, speaking of his Visions, she said, ' You know, dear, the first time you saw God was when you were four years old, and he put his head to the window and set you a-screaming.' In a word, she was formed on the Miltonic model, and like the first Wife Eve worshipped God in her husband. He being to her what God was to him. Vide Milton's Paradise Lost—*passim*.

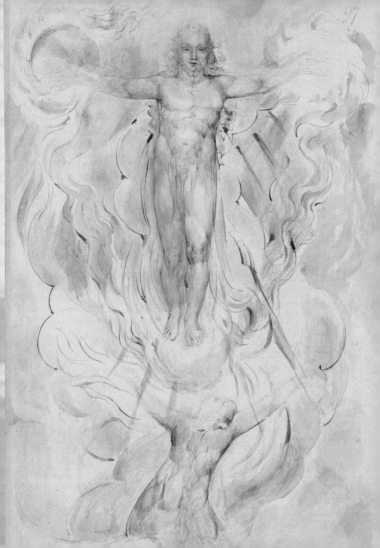

He was making designs or engravings, I forget which. Carey's Dante was before [*sic*]. He showed me some of his designs from Dante, of which I do not presume to speak. They were too much above me. But Götzenberger, whom I afterwards took to see them, expressed the highest admiration of them. They are in the hands of *Linnell* the painter, and, it has been suggested, are reserved by him for publication when Blake may have become an object of interest to a greater number than he could be at this age. *Dante* was again the subject of our conversation. And Blake declared him a mere politician and atheist, busied about this world's affairs; as Milton was till, in his (M.'s) old age, he returned back to the God he had abandoned in childhood. I in vain endeavoured to obtain from him a qualification of the term atheist, so as not to include him in the ordinary reproach. And yet he afterwards spoke of Dante's being *then* with God. I was more successful when he also called Locke an atheist, and imputed to him wilful deception, and seemed satisfied with my admission, that Locke's philosophy led to the Atheism of the French school. He reiterated his former strange notions on morals—would allow of no other education than what lies in the cultivation of

Opposite: Dante adoring Christ, one of 102 illustrations for The Divine Comedy *commissioned by John Linnell, 1824-7*

53

the fine arts and the imagination. 'What are called the Vices in the natural world, are the highest sublimities in the spiritual world.' And when I supposed the case of his being the father of a vicious son and asked him how he would feel, he evaded the question by saying that in trying to think correctly he must not regard his own weaknesses any more than other people's. And he was silent to the observation that his doctrine denied evil. He seemed not unwilling to admit the Manichæan doctrine of two principles, as far as it is found in the idea of the Devil. And said expressly said [*sic*] he did not believe in the omnipotence of God. The language of the Bible is only poetical or allegorical on the subject, yet he at the same time denied the *reality* of the natural world. Satan's empire is the empire of nothing.

As he spoke of frequently seeing Milton, I ventured to ask, half ashamed at the time, which of the three or four portraits in *Hollis's* Memoirs (vols. in 4to) is the most like. He answered, 'They are all like, at different ages. I have seen him as a youth and as an old man with a long flowing beard. He came lately as an old

Opposite: Milton's Mysterious Dream, from a set of illustrations to Milton's poem Il Penseroso *commissioned by Blake's long-term patron, the civil servant Thomas Butts, c. 1816-20*

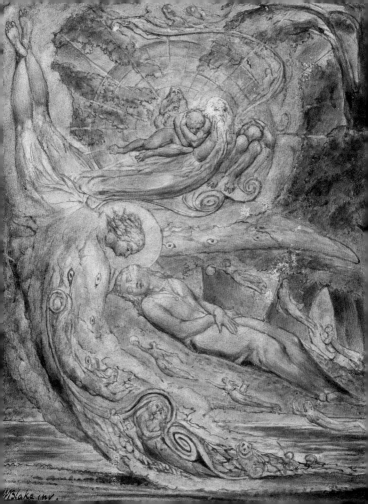

W Blake inv.

man—he said he came to ask a favour of me. He said he had committed an error in his Paradise Lost, which he wanted me to correct, in a poem or picture; but I declined. I said I had my own duties to perform.' It is a presumptuous question, I replied—might I venture to ask—what that could be. 'He wished me to expose the falsehood of his doctrine, taught in the Paradise Lost, that sexual intercourse arose out of the Fall. Now that cannot be, for no good can spring out of evil.' But, I replied, if the consequence were evil, mixed with good, then the good might be ascribed to the common cause. To this he answered by a reference to the *androgynous* state, in which I could not possibly follow him. At the time that he asserted his own possession of this gift of Vision, he did not boast of it as peculiar to himself; all men might have it if they would.

****1826****

On the 24th I called a second time on him. And on this occasion it was that I read to him *Wordsworth's Ode* on the supposed pre-existent State, and the subject of Wordsworth's religious character was discussed when we met on the 18th of Feb., and the 12th of May. I will here bring together Blake's declarations

concerning Wordsworth, and set down his marginalia in the 8vo. edit. A.D. 1815, vol. i. I had been in the habit, when reading this marvellous Ode to friends, to omit one or two passages, especially that beginning:

'But there's a Tree, of many one,'

lest I should be rendered ridiculous, being unable to explain precisely what I admired. Not that I acknowledged this to be a fair test. But with Blake I could fear nothing of the kind. And it was this very stanza which threw him almost into a hysterical rapture. His delight in Wordsworth's poetry was intense. Nor did it seem less, notwithstanding the reproaches he continually cast on Wordsworth for his imputed worship of nature; which in the mind of Blake constituted Atheism.

The combination of the warmest praise with imputations which from another would assume the most serious character, and the liberty he took to interpret as he pleased, rendered it as difficult to be offended as to reason with him. The eloquent descriptions of Nature in Wordsworth's poems were conclusive proofs of atheism, for whoever believes in Nature, said Blake,

disbelieves in God. For Nature is the work of the Devil. On my obtaining from him the declaration that the Bible was the Word of God, I referred to the commencement of Genesis—In the beginning God created the Heavens and the Earth. But I gained nothing by this, for I was triumphantly told that this God was not Jehovah, but the Elohim; and the doctrine of the Gnostics repeated with sufficient consistency to silence one so unlearned as myself.

The Preface to the Excursion, especially the verses quoted from Book I. of the Recluse, so troubled him as to bring on a fit of illness. These lines he singled out:

> Jehovah with his thunder, and the Choir
> Of shouting Angels, and the Empyreal throne,
> I pass them unalarmed.

Does Mr. Wordsworth think he can surpass Jehovah?

There was a copy of the whole passage in his own hand, in the volume of Wordsworth's poems sent to my chambers after his death. There was this note at the end:

> Solomon, when he married Pharaoh's daughter, and became a convert to the Heathen Mythology, talked exactly in this way of Jehovah, as a very inferior object of Man's contemplations; he also passed him

unalarmed, and was permitted. Jehovah dropped a tear and followed him by his Spirit into the abstract void. It is called the Divine Mercy. Sarah dwells in it, but Mercy does not dwell in Him.

Some of Wordsworth's poems he maintained were from the Holy Ghost, others from the Devil. I lent him the 8ᵛᵒ edition, two vols., of Wordsworth's poems, which he had in his possession at the time of his death. They were sent me then. I did not recognise the pencil notes he made in them to be his for some time, and was on the point of rubbing them out under that impression, when I made the discovery.

The following are found in the 3ʳᵈ vol., in the fly-leaf under the words: Poems referring to the Period of Childhood.

> I see in Wordsworth the Natural man rising up against the Spiritual man continually, and then he is no poet, but a Heathen Philosopher at Enmity against all true poetry or inspiration.'

Under the first poem:

> And I could wish my days to be
> Bound each to each by natural piety,

he had written,

> There is no such thing as natural piety, because the natural man is at enmity with God.

P. 43, under the Verses 'To H. C., six years old'—

> This is all in the highest degree imaginative and equal to any poet, but not superior. I cannot think that real poets have any competition. None are greatest in the kingdom of heaven. It is so in poetry.

P. 44, 'On the Influence of Natural Objects,' at the bottom of the page.

> Natural objects always did and now do weaken, deaden, and obliterate imagination in me. Wordsworth must know that what he writes valuable is not to be found in Nature. Read Michael Angelo's sonnet, vol. iv. p. 178.

That is, the one beginning

> No mortal object did these eyes behold
> When first they met the placid light of thine.

It is remarkable that Blake, whose judgements were on most points so very singular, on one subject closely connected with Wordsworth's poetical reputation should have taken a very commonplace view. Over the heading of the 'Essay Supplementary to the Preface' at the end of the vol. he wrote,

> I do not know who wrote these Prefaces; they are very mischievous, and direct contrary to Wordsworth's own practice.

This is not the defence of his own style in opposition to what is called Poetic Diction, but a sort of historic vindication of the *unpopular* poets. On Macpherson Wordsworth wrote with the severity with which all great writers have written of him. Blake's comment below was,

> I believe both Macpherson and Chatterton, that what they say is ancient is so.

And in the following page,

> I own myself an admirer of Ossian equally with any other poet whatever. Rowley and Chatterton also.

And at the end of this Essay he wrote,

> It appears to me as if the last paragraph beginning "Is it the spirit of the whole," etc., was written by another hand and mind from the rest of these Prefaces; they are the opinions of [words missing] landscape-painter. Imagination is the divine vision not of the world, nor of man, nor from man as he is a natural man, but only as he is a spiritual man. Imagination has nothing to do with memory.

* 1826 *

18*th Feb.* It was this day in connection with the assertion that* the Bible is the Word of God and all truth is

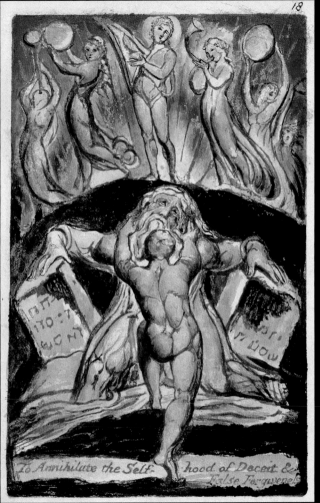

To Annihilate the Self- hood of Deceit &
 False Forgiveness

to be found in it, he using language concerning man's reason being opposed to grace very like that used by the Orthodox Christian, that he qualified, and as the same Orthodox would say utterly nullified all he said by declaring that he understood the Bible in a Spiritual sense. As to the natural sense, he said *Voltaire* was commissioned by God to expose that. 'I have had,' he said, 'much intercourse with Voltaire, and he said to me, "I blasphemed the Son of Man, and it shall be forgiven me, but they (the enemies of Voltaire) blasphemed the Holy Ghost in me, and it shall not be forgiven to them."' I ask him in what language Voltaire spoke. His answer was ingenious and gave no encouragement to cross-questioning: 'To my sensations it was English. It was like the touch of a musical key; he touched it probably French, but to my ear it became English.' I also enquired as I had before about the form of the persons who appeared to him, and asked why he did not *draw* them. 'It is not worth while,' he said. 'Besides there are so many that the labour would be too great. And there would be no use in it.' In answer to an enquiry about Shakespeare, 'he is exactly like the old engraving—which is said to

Opposite: 'To Annihilate the Self-hood of Deceit and False Forgiveness' from Milton a Poem (probably 1804-11, printed 1818 for Thomas Vine, a merchant and landowner on the Isle of Wight

be a bad one. I think it very good.' I enquired about his own writings. 'I have written,' he answered, 'more than Rousseau or Voltaire—six or seven Epic poems as long as Homer and 20 Tragedies as long as Macbeth.' He shewed me his 'Version of Genesis,' for so it may be called, as understood by a Christian Visionary. He read a wild passage in a sort of Bible style. 'I shall print no more,' he said. 'When I am commanded by the Spirits, then I write, and the moment I have written, I see the words fly about the room in all directions. It is then published. The Spirits can read, and my MS. is of no further use. I have been tempted to burn my MS., but my wife won't let me.' She is right, I answered; you write not from yourself but from higher order. The MSS. are their property, not yours. You cannot tell what purpose they may answer. This was addressed *ad hominem*. And it indeed amounted only to a deduction from his own principles. He incidentally denied *causation*, every thing being the work of God or Devil. Every man has a Devil in himself, and the *conflict* between his *Self* and God is perpetually going on. I ordered of him to-day a copy of his songs for 5 guineas. My manner of receiving his mention of price pleased him. He spoke of his horror of money and of turning pale when it was offered him, and this was certainly unfeigned.

In the No. of the *Gents. Magazine* for last Jan. there is a letter by *Cromek* to Blake printed in order to convict Blake of selfishness. It cannot possibly be substantially true. I may elsewhere notice it.

13*th June.* I saw him again in June. He was as wild as ever, says my journal, but he was led to-day to make assertions more palpably mischievous, if capable of influencing other minds, and immoral, supposing them to express the will of a responsible agent, than anything he had said before. As, for instance, that he had learned from the Bible that Wives should be in common. And when I objected that marriage was a Divine institution, he referred to the Bible—'that from the beginning it was not so.' He affirmed that he had committed many murders, and repeated his doctrine, that reason is the only sin, and that careless, gay people are better than those who think, etc. etc.

It was, I believe, on the 7th of December that I saw him last. I had just heard of the death of Flaxman, a man whom he professed to admire, and was curious to know how he would receive the intelligence. It was as I expected. He had been ill during the summer, and he said with a smile, 'I thought I should have gone first.' He then said, 'I cannot think of death as more than the going out of one room into another.' And Flaxman was no longer thought of. He relapsed

into his ordinary train of thinking. Indeed I had by this time learned that there was nothing to be gained by frequent intercourse. And therefore it was that after this interview I was not anxious to be frequent in my visits. This day he said, 'Men are born with an Angel and a Devil.' This he himself interpreted as Soul and Body, and as I have long since said of the strange sayings of a man who enjoys a high reputation, 'it is more in the language than the thought that this singularity is to be looked for.' And this day he spoke of the Old Testament as if [*sic*] were the evil element. Christ, he said, took much after his mother, and in so far was one of the worst of men. On my asking him for an instance, he referred to his turning the money-changers out of the Temple—he had no right to do that. He digressed into a condemnation of those who sit in judgement on others. 'I have never known a very bad man who had not something very good about him.'

Speaking of the Atonement in the ordinary Calvinistic sense, he said, 'It is a horrible doctrine; if another pay your debt, I do not forgive it.'

Opposite: Then the Divine Hand Found the Two Limits, Satan and Adam (The creation of Eve), from Jerusalem The Emanation of The Giant Albion, *1804-20, this copy printed c. 1821*

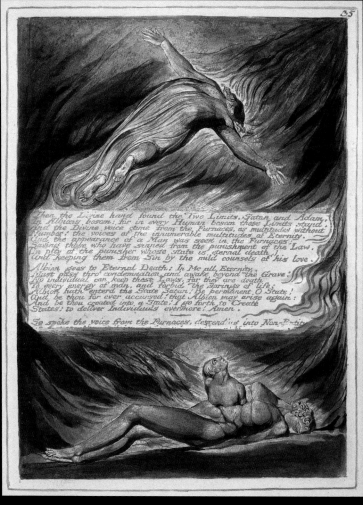

Then the Divine hand found the Two Limits, Satan and Adam,
In Albions bosom: for in every Human bosom those Limits stand.
And the Divine voice came from the Furnaces, as multitudes without
number! the voices of the innumerable multitudes of Eternity,
And the appearance of a Man was seen in the Furnaces;
Saving those who have sinned from the punishment of the Law,
(In pity of the punisher whose state is eternal death,)
And keeping them from Sin by the mild counsels of his love.

Albion goes to Eternal Death: In Me all Eternity.
Must pass thro' condemnation, and awake beyond the Grave!
No individual can keep these Laws, for they are death
To every energy of man, and forbid the springs of life;
Albion hath enterd the State Satan! Be permanent O State!
And be thou for ever accursed! that Albion may arise again:
And be thou created into a State! I go forth to Create
States: to deliver Individuals evermore! Amen.

So spoke the voice from the Furnaces, descending into Non-Entity

Hell is naked before him & Destruction has no covering

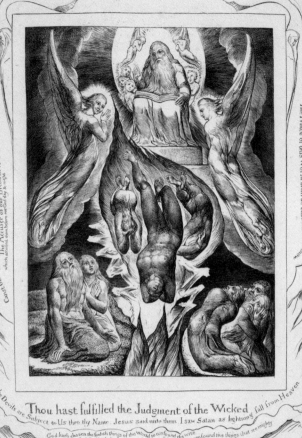

Canst thou by searching find out God Canst thou find out the Almighty to perfection

The Accuser of our Brethren is Cast down

which accused them before our God day & night

Is it higher than Heaven what canst thou do

It is deeper than Hell what canst thou know

The Prince of this World shall be cast out

From the Devils are Subject to Us thro thy Name Jesus said unto them I saw Satan as lightning fall from Heaven

Thou hast fulfilled the Judgment of the Wicked

God hath chosen the foolish things of the World to confound the wise
And God hath chosen the weak things of the World to confound the things that are mighty

WBlake inv & sculp

London, Published as the Act directs March 8. 1825 by William Blake N.3 Fountain Court Strand

Pro

I have no account of any other call—but there is probably an omission. I took Götzenberger to see him, and he met the Masqueriers in my chambers. Masquerier was not the man to meet him. He could not humour Blake nor understand the peculiar sense in which he was to be received.*

* 1827 *

My journal of this year contains nothing about Blake. But in January 1828 Barron Field and myself called on Mrs. Blake. The poor old lady was more affected than I expected she would be at the sight of me. She spoke of her husband as dying like an angel. She informed me that she was going to live with Linnell as his housekeeper. And we understood that she would live with him, and he, as it were, to farm her services and take all she had. The engravings of Job were his already. Chaucer's Canterbury Pilgrims were hers.

I took two copies—one I gave to C. Lamb. Barron Field took a proof.

Mrs. Blake died within a few years, and since Blake's death Linnell has not found the market I took

Opposite: The Fall of Satan, from the Illustrations to the Book of Job, 1823-6, commissioned by John Linnell

for granted he would seek for Blake's works. Wilkinson printed a small edition of his poems, including the 'Songs of Innocence and Experience,' a few years ago, and Monkton Mylne talks of printing an edition. I have a few coloured engravings—but Blake is still an object of interest exclusively to men of imaginative taste and psychological curiosity. I doubt much whether these mems. will be of any use to this small class. I have been reading since the Life of Blake by Allan Cuningham, vol. ii. p. 143 of his Lives of the Painters. It recognises more perhaps of Blake's merit than might be expected of a *Scotch* realist.

HENRY CRABB ROBINSON

William Blake: Artist, Poet, and Religious Mystic

1810

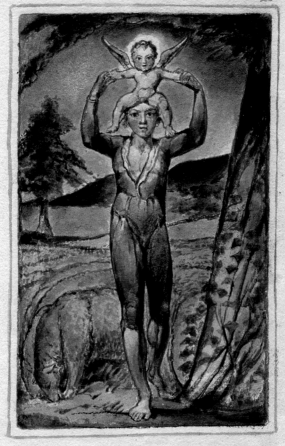

The lunatic, the lover, and the poet
Are of imagination all compact
Shakespeare

O f all the conditions which arouse the interest of the psychologist, none assuredly is more attractive than the union of genius and madness in single remarkable minds, which, while on the one hand they compel our admiration by their great mental powers, yet on the other move our pity by their claims to supernatural gifts. Of such is the whole race of ecstatics, mystics, seers of visions and dreamers of dreams, and to their list we have now to add another name, that of William Blake.

This extraordinary man, who is at this moment living in London, although no more than fifty years of age is only now beginning to emerge from the obscurity in which the singular bent of his talents and the eccentricity of his personal character have confined him. We know too little of his history to claim to give

Opposite: Frontispiece of Songs of Experience, *1794, from a copy printed and coloured by Blake in 1826 and sold to Crabb Robinson. The image is approximately actual size*

a complete account of his life, and can do no more than claim to have our information on very recent authority. It must suffice to know by way of introduction that he was born in London of parents of moderate means, and early gave himself up to his own guidance, or rather, misguidance. In his tenth year he went to a drawing school, in his fourteenth (as apprentice) to an engraver of the name of Basire, well known by his plates to Stuart's 'Athens' and his engraving of West's 'Orestes and Pylades.' Even as a boy, Blake was distinguished by the singularity of his taste. Possessed with a veritable passion for gothic architecture, he passed whole days in drawing the monuments in Westminster Abbey. In addition he collected engravings, especially after Raphael and Michael Angelo, and idolised Albert Dürer and Heemskerk.

Although he afterwards worked as a student at the Royal Academy, he had already shown his bent to an art so original that, isolated from his fellow-students, he was far removed from all regular or ordinary occupation. His name is nevertheless to be found under some very commonplace plates to children's books;*

* Possibly Blake's own works *For Children: the Gates of Paradise*, (1793) or Mary Wollstonecraft's *Tales for Children* (1791).

Frontispiece to Blake's The Gates of Paradise,
first printed 1793 as reworked with a caption c. 1810-20

but while he cherished artistic visions utterly opposed to the taste of connoisseurs, and regarded more recent methods in drawing and engraving as sins against art, he preferred, in his phrase, to be a martyr for his religion—i.e., his art—to debasing his talents by a weak submission to the prevailing fashion of art in an age of artistic degradation. Moreover, as his religious convictions had brought on him the credit of being an absolute lunatic, it is hardly to be wondered that, while professional connoisseurs know nothing of him, his very well-wishers cannot forbear betraying their compassion, even while they show their admiration. One attempt at introducing him to the great British public has indeed succeeded, his illustrations to Blair's 'Grave,' a religious poem very popular among the serious, which connoisseurs find remarkable alike for its beauty and defects, blaming its want of taste and delicacy, while admiring the imaginative power of the poet. Blake, although properly speaking an engraver, was not commissioned to engrave his own drawings, the execution being entrusted, for reasons which we shall soon hear, to Schiavonetti, who executed his task with great neatness, but with such an admixture of dots and lines as must have aroused the indignation of

Opposite: Title page design for Robert Blair's The Grave, *1806*

The Grave
a Poem

By Robert Blair

Illustrated with 12 Engravings

by Louis Schiavonetti

From the Original Inventions

of

William Blake.

1806.

the artist. This work, which besides the twelve draw-
ings contains an excellent portrait of Blake and the
original text, costs two and a half guineas.* It is pre-
ceded by some remarks of Fuseli's, which we insert as
a proof of the merits of our artist, since we cannot
give an actual reproduction of his work. After men-
tioning the utility of such a series of moral designs in
an age so frivolous as ours, before which the allegories
of antiquity faint and fail, Fuseli continues,

> the author of the moral series before us has endeav-
> oured to wake sensibility by touching our sympathies
> with nearer, less ambiguous, and less ludicrous im-
> agery, than that which mythology, Gothic supersti-
> tion, or symbols as far-fetched as inadequate, could
> supply. His invention has been chiefly employed to
> spread a familiar and domestic atmosphere round
> the most important of all subjects, to connect the
> visible and the invisible world, without provoking
> probability, and to lead the eye from the milder light
> of time to the radiations of eternity.
>
> Such is the plan and the moral part of the au-
> thor's invention; the technic part, and the execution
> of the artist, though to be examined by other prin-
> ciples, and addressed to a narrower circle, equally
> claim approbation, sometimes excite our wonder,

* Illustrations commissioned 1805 and book published 1808

and not seldom our fears, when we see him play on the very verge of legitimate invention; but wildness so picturesque in itself, so often redeemed by taste, simplicity, and elegance, what child of fancy, what artist would wish to discharge? The groups and single figures on their own basis, abstracted from the general composition, and considered without attention to the plan, frequently exhibit those genuine and unaffected attitudes, those simple graces which nature and the heart alone can dictate, and only an eye inspired by both, discover. Every class of artists, in every stage of their progress or attainments, from the student to the finished master, and from the contriver of ornament, to the painter of history, will find here materials of art and hints of improvement!!

One can see this is no 'damning with feigned praise,' for the faults indicated by Fuseli are only too apparent. In fact, of all the artists who ever lived, even of those perverted spirits described by Goethe in his entertaining 'Sammler und die Seinigen' under the title of poetisers, phantom-hunters and the like, none so completely betrays himself as our artist. We shall return to these drawings later, and will now proceed

* 'The collector and his own', published in Goethe's journal *Propyläen* in 1799

to speak of the little book on which we have specially drawn, a book, besides, which is one of the most curious ever published.

The illustrations to the 'Grave,' though only perhaps admired by the few, were by these few loudly and extravagantly praised. Blake, who had become known by their praises, now resolved to come forward. Only last year he opened an exhibition of his frescoes, proclaiming that he had rediscovered the lost art of fresco. He demanded of those who had considered his works the slovenly daubs of a madman, destitute alike of technical skill and harmony of proportion, to examine them now with greater attention. 'They will find,' he adds, 'that if Italy is enriched and made great by Raphael, if Michael Angelo is its supreme glory, if art is the glory of the nation, if genius and inspiration are the great origin and bond of society, the distinction my works have obtained from those who best understand such things calls for my exhibition as the greatest of duties to my country.'*

At the same time he published a 'Descriptive Catalogue' of these fresco pictures, out of which we propose to give only a few unconnected passages. The

* Not in the *Descriptive Catalogue*, but possibly recorded by Robinson on 15 May 1809

original consists of a veritable olio of fragmentary utterances on art and religion, without plan or arrangement, and the artist's idiosyncracies will in this way be most clearly shown.

The vehemence with which, throughout the book, he declaims against oil painting and the artists of the Venetian and Flemish schools is part of the fixed ideas of the author. His preface begins with the following words:*—'The eye which prefers the colouring of Rubens and Titian to that of Raphael and Michael Angelo should be modest and mistrust its own judgement,' but as he proceeds with his descriptions his wrath against false schools of painting waxes, and in holy zeal he proclaims that the hated artists are evil spirits, and later art the offspring of hell. Chiaroscuro he plainly calls 'an infernal machine in the hand of Venetian and Flemish demons.' The following will make it appear that these expressions are not merely theoretical phrases. Correggio he calls 'a soft, effeminate, and consequently most cruel demon.' Rubens is 'a most outrageous demon.' These artists are, next to Titian and Rembrandt, the continuing objects of his criticism, and finally he declares 'till we get rid of [Titian and Correggio, Rubens and Rembrandt], we

* Not in the *Descriptive Catalogue*

shall never equal Rafael, and Albert Durer, Michael Angelo, and Julio Romano'. He does not conceal the ground of this preference, and the following passage, while it reveals the artist's views on the technique of his art, contains a truth which cannot be denied, and which underlies his whole doctrine.

The great and golden rule of art, as well as life, is this: That the more distinct, sharp and wiry the bounding line, the more perfect the work of art ; and the less keen and sharp, the greater is the evidence of weak imitation, plagiarism, and bungling. Great inventors, in all ages, knew this : Protogenes and Apelles knew each other by this line. Rafael and Michael Angelo, and Albert Durer, are known by this and this alone. The want of this determinate and bounding form evidences the want of idea in the artist's mind, and the pretence of the plagiary in all its branches. How do we distinguish the oak from the beech, the horse from the ox, but by the bounding outline? [...] What is it that builds a house and plants a garden, but the definite and determinate? What is it that distinguishes honesty from knavery, but the hard and wiry line of rectitude and certainty in the actions and intentions? Leave out this line and you leave out life itself; all is chaos again, and the line of the Almighty must be drawn out upon it before man or beast can exist. Talk no more of Correggio, or Rembrandt, or any any

other of those plagiaries of Venice or Flanders. They were but the lame imitators of early lines drawn by their predecessors...

This passage is sufficient to explain why our artist was not permitted to engrave his own designs.* In the same spirit he proclaims the guilt of the recent distinction between a painting and a drawing. 'If losing and obliterating the outline constitutes a picture, Mr. B. will never be so foolish as to do one.... There is no difference between Raphael's Cartoons and his Frescoes or Pictures, except that the Frescos or Pictures are more highly finished.' He denies Titian, Rubens and Correggio all merit in colouring, and says, 'their men are like leather and their women like chalk.' In his own principal picture his naked forms are almost crimson. They are Ancient Britons, of whom he says,

the flush of health in flesh, exposed to the open air, nourished by the spirits of forests and floods, in that ancient happy period which history has recorded, cannot be like the sickly daubs of Titian or Rubens. As to modern man, stripped from his load of clothing, he is like a dead corpse.

We now pass from the technique of his art to the meaning and poetical portions in which the

*That is, for Robert Blair's *The Grave*

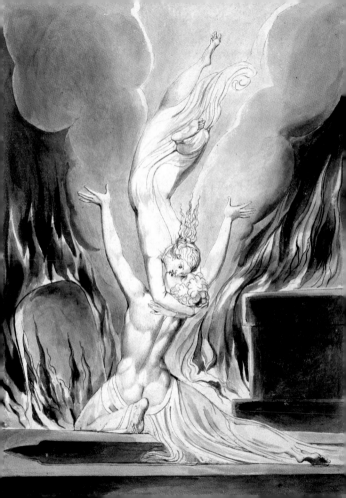

peculiarities of our artist are still more clearly seen. His greatest enjoyment consists in giving bodily form to spiritual beings. Thus in the 'Grave' he has represented the re-union of soul and body, and to both he has given equal clearness of form and outline. In one of his best drawings, the 'Death of the Strong Wicked Man,' the body lies in the death agony, and a broken vessel, whose contents are escaping, indicates the moment of death, while the soul, veiled in flame, rises from the pillow. The soul is a copy of the body, yet in altered guise, and flies from the window with a well-rendered expression of horror. In other engravings the soul appears hovering over the body, which it leaves unwillingly; in others we have the Re-union of both at the Resurrection and so forth. These are about the most offensive of his inventions.

In his Catalogue we find still further vindication of the reproaches brought against his earlier work. 'Shall painting be confined to the sordid drudgery of fac-simile representations of merely mortal and perishing substances, and not be, as poetry and music are, elevated into its own proper sphere of invention and visionary conception?' He then alleges that the statues

Opposite: The Reunion of the Soul and the Body, watercolour for illustration to Robert Blair's The Grave, *1805*

The Death of the Strong Wicked Man, watercolour for illustration to Robert Blair's The Grave, *1805*

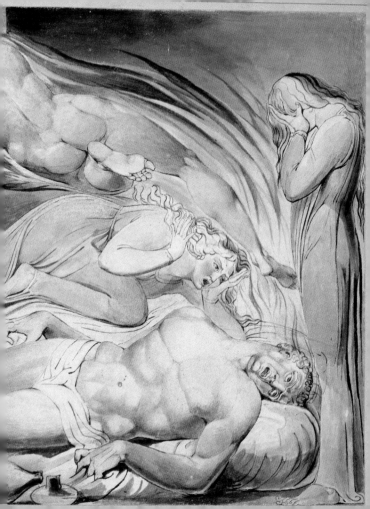

of the Greek gods are so many bodily representations of spiritual beings.

> A Spirit and a Vision are not, as the modern philosophy supposes, a cloudy vapour or a nothing: they are organised and minutely articulated beyond all that the mortal and perishing nature can produce. He who does not imagine in stronger and better lineaments, and in stronger and better light than his perishing mortal eyes can see does not imagine at all. The painter of this work asserts that all his imaginations appear to him infinitely more perfect and more minutely organized than anything seen by his mortal eye. Spirits are organised men [...].'

In a certain sense every imaginative artist must maintain the same, but it will always remain doubtful in what sense our artist uses these expressions. For in his own description of his allegorical picture of Pitt guiding Behemoth,[1] and Nelson Leviathan[2] (pictures which the present writer, although he has seen them, dares not describe) he says, 'these pictures are similar to those Apotheoses of Persian, Hindoo, and

1. *The Spiritual Form of Pitt Guiding Behemoth*, c. 1805, Tate, London
2. *The Spiritual Form of Nelson Leading Leviathan*, c. 1805, Tate, London

Opposite: The Spiritual Form of Pitt Guiding Behemoth, c. 1805

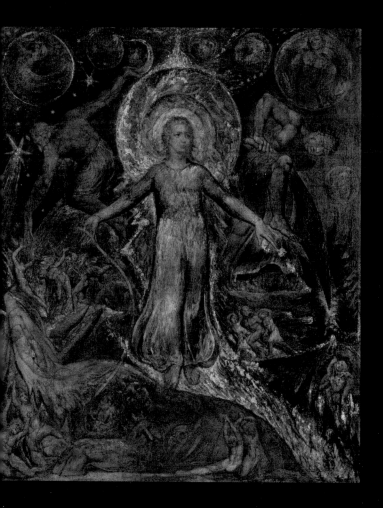

Egyptian antiquity, which are still preserved on rude monuments.' He adds:

> The Artist having been taken in vision into the ancient republics, monarchies, and patriarchates of Asia, has seen those wonderful originals, called in the Sacred Scriptures the Cherubim, which were sculptured and painted on walls of Temples [...], and erected in the highly cultivated States of Egypt, Moab, Edom, Aram, among the Rivers of Paradise—being originals from which the Greeks and Hetrurians copied Hercules Farnese [...] and all the grand works of ancient art. [...] Perhaps the Torso is the only original work remaining; all the rest are evidently copies. [...] The Greek Muses are daughters of Mnemosyne or Memory, and not of Inspiration or Imagination, therefore not authors of such sublime conceptions.

As this belief of our artist's in the intercourse which, like Swedenborg, he enjoys with the spiritual world has more than anything else injured his reputation, we subjoin another remarkable passage from his Catalogue.

His greatest and most perfect work is entitled 'The Ancient Britons'.[1] It is founded on that strange survival of Welsh bardic lore which Owen gives thus under the name of Triads:

1. Lost

In the last battle that Arthur fought, the most beauti-
 ful was one
That returned, and the most strong another: with
 them also returned
The most ugly; and no other beside returned from
 the bloody field.
The most beautiful, the Roman warriors trembled
 before and worshipped;
The most strong they melted before and dissolved in
 his presence;
The most ugly they fled with outcries and contortions
 of their limbs.

This dark passage gives way to a yet darker com-
mentary:

The Strong man represents the human sublime. The
Beautiful man represents the human pathetic, which
was in the wars of Eden divided into male and fe-
male. The Ugly man represents the human reason.
They were originally one man, who was fourfold; he
was self-divided, and his real humanity slain on the
stems of generation, and the form of the fourth was
like the Son of God. How he became divided is a
subject of great sublimity and pathos. The Artist has
written it under inspiration, and will, if God please,
publish it; it is voluminous, and contains the ancient

Overleaf: Plate 100 from Jerusalem, *showing Los's spectre, Los and Enithar-
 mon before the 'serpent temple', 1804-c. 1820, probably printed c. 1821*

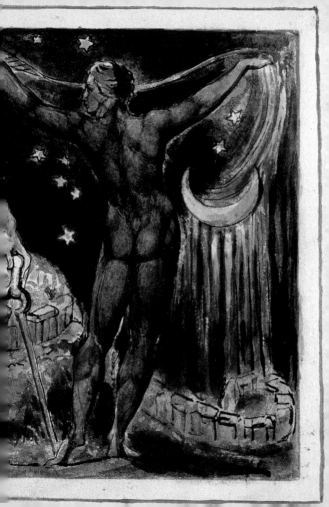

history of Britain, and the world of Satan and of Adam.

The picture represents these three beings fighting with the Romans; but we prefer to let the artist speak of his own works.

> It has been said to the Artist, take the Apollo for the model of your beautiful Man and the Hercules for your strong Man, and the Dancing Fawn for your Ugly Man. Now he comes to his trial. He knows that what he does is not inferior to the grandest Antiques. Superior they cannot be, for human power cannot go beyond either what he does, or what they have done, it is the gift of God, it is inspiration and vision. [...] Poetry as it exists now on earth, in the various remains of ancient authors, Music as it exists in old tunes or melodies, Painting and Sculpture as it exists in the remains of Antiquity [...] is Inspiration, and cannot be surpassed; it is perfect and eternal. Milton, Shakspeare, Michael Angelo, Rafael, the finest specimens of Ancient Sculpture and Painting, and Architecture, Gothic, Grecian, Hindoo and Egyptian, are the extent of the human mind. The human mind cannot go beyond the gift of God, the Holy Ghost.

Elsewhere he says that Adam and Noah were Druids, and that he himself is an inhabitant of Eden.

Blake's religious convictions appear to be those of an orthodox Christian; nevertheless, passages concerning

earlier mythologies occur which might cast a doubt on it. These passages are to be found in his Public Address on the subject of this picture of Chaucer's Pilgrims, certainly the most detailed and accurate of his works since, kept within limits by his subject, he could not run riot in his imagination. We look forward to seeing this particular print, for which subscribers have bene found, brought to completion. been . He remarks, every one of Chaucer's characters 'is an Antique Statue; the image of a class, and not of an imperfect individual.' At the same time he claims that they are also the characters of Greek mythology.

> Chaucer has divided the ancient character of Hercules between his Miller and his Plowman. [...] The Plowman is Hercules in his supreme eternal state, divested of his spectrous shadow; which is the Miller, a terrible fellow, such as exists in all times and places, for the trial of men, to astonish every neighbourhood, with brutal strength and courage, to get rich and powerful to curb the pride of Man,' while 'benevolence is the plowman's great characteristic. [...] Visions of these eternal principles or characters of human life appear to poets in all ages; the Grecian gods were the ancient Cherubim of Phœnicia; but the Greeks, and since them the Moderns, have neglected to subdue the gods of Priam. These Gods are visions of the eternal attributes, or divine names, which, erected

into gods, become destructive to humanity. They ought to be the servants, and not the masters of man, or of society. They ought to be made to sacrifice to Many, and not man compelled to sacrifice to them; for when separated from man or humanity, who is Jesus the Saviour, the vine of eternity, they are thieves and rebels, they are destroyers.

These passages could be explained as the diatribes of a fervid monotheist against polytheism; yet, as our author elsewhere says, 'The antiquities of every nation under the Heaven are no less sacred than those of the Jews,' his system remains more allied to the stoical endurance of Antiquity than to the essential austerity of Christianity.

These are the wildest and most extravagant passages of the book, which lead to the consideration with which we began this account. No one can deny that, as even amid these aberrations gleams of reason and intelligence shine out, so a host of expressions occur among them which one would expect from a German rather than an Englishman. The Protestant author of *Outpourings of an Art-Loving Friar** created the character of a Catholic in whom religion and love

Herzensergiessungen eines Kunstliebenden Klosterbruders by W. G. Wackenroder, 1797, a founding text of German Romanticism

of art were perfectly united, and this identical person, singularly enough, has turned up in Protestant England. Yet Blake does not belong by birth to the established church, but to a dissenting sect; although we do not believe that he goes regularly to any Christian church. He was invited to join the Swedenborgians under Proud,* but declined, notwithstanding his high opinion of Swedenborg, of whom he says: 'The works of this visionary are well worth the attention of Painters and Poets; they are foundations for grand things. The reason they have not been more attended to is because corporal demons have gained a predominance.' Our author lives, like Swedenborg, in communion with the angels. He told a friend, from whose mouth we have the story, that once when he was carrying home a picture which he had done for a lady of rank, and was wanting to rest in an inn, the angel Gabriel touched him on the shoulder and said, 'Blake, wherefore art thou here? Go to, thou shouldst not be tired.' He arose and went on unwearied. This very conviction of supernatural suggestion makes him deaf to the voice of the connoisseur, since to any reproach directed against his works he makes answer,

* Joseph Proud (1745-1826), minister of the Swedenborgian New Church.

why it cannot in the nature of things be a failure. 'I know that it is as it should be, since it adequately reproduces what I saw in a vision, and must therefore be beautiful.'

It is needless to enumerate all Blake's performances. The most famous we have already mentioned, and the rest are either allegorical or works of the pen. We must, however, mention one other of his works before ceasing to discuss him as an artist. This is a most remarkable edition of the first four books of Young's 'Night Thoughts,' which appeared in 1797, and is no longer to be bought, so excessively rare has it become. In this edition the text is in the middle of the page; above and below it are engravings by Blake after his own drawings. They are of very unequal merit; sometimes the inventions of the artist rival those of the poet, but often they are only preposterous translations of them, by reason of the unfortunate idea peculiar to Blake, that whatsoever the fancy of the spiritual eye may discern must also be as clearly penetrable to the bodily eye. So Young is literally translated, and his thought turned into a picture. Thus for example the artist represents in a drawing Death treading crowns

Opposite: Cynthia, goddess of the moon, watercolour for illustration to 'Night the Third' of Young's Night Thoughts, *c. 1795-7. For reverse of this page see p. 100*

NIGHT THE THIRD.

NARCISSA.

Humbly Inscrib'd to her GRACE

The DUTCHESS of P------.

Ignoscenda quidem, scirent si ignoscere Manes.
VIRG.

The SECOND EDITION.

LONDON:

Printed for R. DODSLEY, at *Tully's* Head in *Pall-Mall*, and
T. COOPER, at the *Globe* in *Pater-Nester-Row*.

M,DCC,XLII.

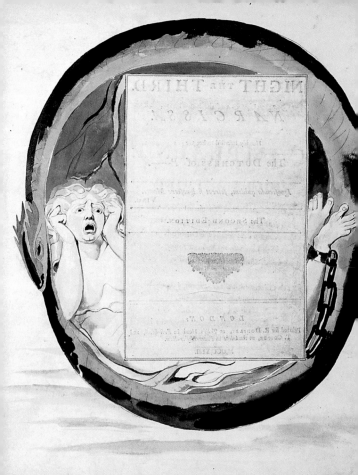

under foot, the sun reaching down his hand, and the like. Yet these drawings are frequently exquisite. We hear that the publisher has not yet issued a quarter of the drawings delivered to him by the artist, and has refused to sell the drawings, although a handsome sum was offered him for them.

We have now to introduce our artist as poet, so as to be able to give some examples of his work in this branch of art, since he himself has published nothing in the proper sense of the word. The poems breathe the same spirit and are distinguished by the same peculiarities as his drawings and prose criticisms. As early as 1783 a little volume was printed with the title of *Poetical Sketches, by W. B.* No printer's name is given on the title-page, and in the preface it states that the poems were composed between his thirteenth and twentieth years. They are of very unequal merit. The metre is usually so loose and careless as to betray a total ignorance of the art, whereby the larger part of the poems are rendered singularly rough and unat-tractive. On the other hand, there is a wildness and loftiness of imagination in certain dramatic fragments

Opposite: Watercolour for illustration for reverse of title page of 'Night the Third' illustrated on p. 99

which testifies to genuine poetical feeling. An example may serve as a measure of the inspiration of the poet at this period.

To the Muses.

Whether on Ida's shady brow,
Or in the chambers of the East,
The Chambers of the Sun, that now
From ancient melody have ceased;

Whether in heaven ye wander fair,
Or the green corners of the Earth,
Or the blue regions of the air.
Where the melodious winds have birth;

Whether on christal rocks ye rove,
Beneath the bosom of the sea,
Wand'ring in many a coral grove;
Fair Nine, forsaking Poetry!

How have you left the ancient love,
That bards of old enjoyed in you?
The languid strings do scarcely move,
The sound is forced, the notes are few .

A still more remarkable little book of poems by our author exists, which is only to be met with in the

hands of collectors. It is a duodecimo entitled '*Songs of Innocence and Experience, shewing the two contrary states of the human soul. The Author and printer W. Blake.*' The letters appear to be etched, and the book is printed in yellow. Round and between the lines are all sorts of engravings; sometimes they resemble the monstrous hieroglyphs of the Egyptians, sometimes they represent not ungraceful arabesques. Wherever an empty space is left after the printing a picture is inserted. These miniature pictures are of the most vivid colours, and often grotesque, so that the book presents a most singular appearance. It is not easy to form a comprehensive opinion of the text, since the poems deserve the highest praise and—the gravest censure. Some are childlike songs of great beauty and simplicity; these are the Songs of Innocence, many of which, nevertheless, are excessively childish. The Songs of Experience, on the other hand, are metaphysical riddles and mystical allegories. Among them are poetic pictures of the highest beauty and sublimity; and again there are poetical fancies which can scarcely be understood even by the initiated.

As we wish to make the knowledge of our author as complete as possible, we will give an example of either kind. The book has an Introduction from which

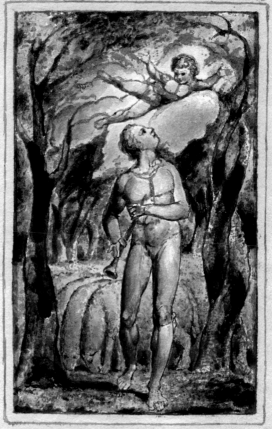

we here insert the first and the two last stanzas (the fourth and fifth).

> Piping down the valleys wild,
> Piping songs of pleasant glee,
> On a cloud I saw a child,
> And he laughing said to me:
>
> 'Piper, sit thee down and write
> In a book that all may read.'
> So he vanished from my sight,
> And I plucked a hollow reed,
>
> And I made a rural pen,
> And I stained the water clear,
> And I wrote my happy songs,
> Every child may joy to hear.

We can only give one more example of these joyous and delicious songs, that called 'Holy Thursday,' which describes the procession of children from all the charity schools to St. Paul's Cathedral which always takes place on this day.

Opposite: Frontispiece to Songs of Innocence: *The Piper and the Child, 1789 but incorporated in Crabb Robinson's copy of* Songs of Innocence and of Experience, *printed in 1826*

Holy Thursday

Twas on a Holy Thursday their innocent faces clean
The children walking two & two in red & blue & green
Grey-headed beadles walkd before with wands as white
 as snow,
Till into the high dome of Pauls they like Thames
 waters flow

O what a multitude they seemd these flowers of
 London town
Seated in companies they sit with radiance all their
 own
The hum of multitudes was there but multitudes of
 lambs
Thousands of little boys & girls raising their innocent
 hands

Now like a mighty wind they raise to heaven the voice
 of song
Or like harmonious thunderings the seats of Heaven
 among
Beneath them sit the aged men wise guardians of the
 poor
 Then cherish pity, lest you drive an angel from your
 door

Opposite: 'Holy Thursday' from Songs of Innocence, *1789,*
from Crabb Robinson's copy of Songs of Innocence
and of Experience, *printed in 1826*

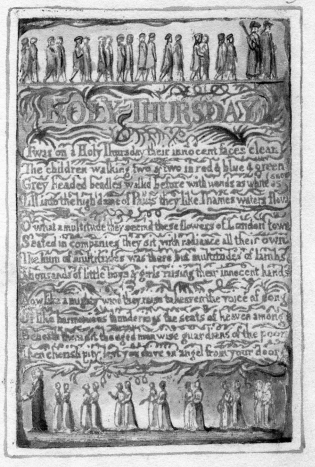

HOLY THURSDAY

Twas on a Holy Thursday their innocent faces clean
The children walking two & two in red & blue & green
Grey headed beadles walked before with wands as white as snow
Till into the high dome of Pauls they like Thames waters flow

O what a multitude they seemd these flowers of London town
Seated in companies they sit with radiance all their own
The hum of multitudes was there but multitudes of lambs
Thousands of little boys & girls raising their innocent hands

Now like a mighty wind they raise to heaven the voice of song
Or like harmonious thunderings the seats of heaven among
Beneath them sit the aged men wise guardians of the poor
Then cherish pity, lest you drive an angel from your door

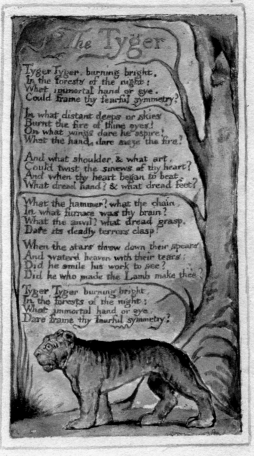

The Tyger

Tyger Tyger, burning bright,
In the forests of the night;
What immortal hand or eye.
Could frame thy fearful symmetry?

In what distant deeps or skies
Burnt the fire of thine eyes?
On what wings dare he aspire?
What the hand, dare seize the fire?

And what shoulder, & what art,
Could twist the sinews of thy heart?
And when thy heart began to beat,
What dread hand? & what dread feet?

What the hammer? what the chain,
In what furnace was thy brain?
What the anvil? what dread grasp,
Dare its deadly terrors clasp?

When the stars threw down their spears
And watered heaven with their tears:
Did he smile his work to see?
Did he who made the Lamb make thee?

Tyger Tyger burning bright,
In the forests of the night:
What immortal hand or eye,
Dare frame thy fearful symmetry?

We cannot better set forth the many-sided gifts of our poet than by following up this singularly delicate and simple poem, with this truly inspired and original description of the Tiger.

The Tyger

Tyger Tyger, burning bright,
In the forests of the night;
What immortal hand or eye,
Could frame thy fearful symmetry?

In what distant deeps or skies.
Burnt the fire of thine eyes?
On what wings dare he aspire?
What the hand, dare seize the fire?

And what shoulder, & what art,
Could twist the sinews of thy heart?
And when thy heart began to beat,
What dread hand? & what dread feet?

What the hammer? what the chain,
In what furnace was thy brain?
What the anvil? what dread grasp,
Dare its deadly terrors clasp!

Opposite: 'The Tyger', from Crabb Robinson's copy of Songs of Experience, *printed in 1794*

When the stars threw down their spears
And water'd heaven with their tears:
Did he smile his work to see?
Did he who made the Lamb make thee?

Tyger Tyger burning bright,
In the forests of the night:
What immortal hand or eye,
Dare frame thy fearful symmetry?

Of the allegorical poems we prefer to give one which we think we understand, rather than one which is to us wholly incomprehensible. The following Song of Experience probably represents man after the loss of his innocence, as, bound by the commandment and the priests its servants, he looks back longing to his earlier state, where before was no commandment, no duty, and naught save love and voluntary sacrifice.

The Garden of Love.

I went to the Garden of Love,
And saw what I never had seen:
A Chapel was built in the midst,
Where I used to play on the green.

Opposite: 'The Garden of Love', from Crabb Robinson's copy of
Songs of Experience, *1794, printed in 1826*

The GARDEN of LOVE

I went to the Garden of Love.
And saw what I never had seen:
A Chapel was built in the midst,
Where I used to play on the green.

And the gates of this Chapel were shut,
And Thou shalt not. writ over the door;
So I turnd to the Garden of Love,
That so many sweet flowers bore.

And I saw it was filled with graves,
And tomb-stones where flowers should be:
And Priests in black gowns, were walking their
 rounds.
And binding with briars, my joys & desires.

And the gates of this Chapel were shut,
And Thou shalt not. writ over the door;
So I turn'd to the Garden of Love,
That so many sweet flowers bore.

And I saw it was filled with graves,
And tomb-stones where flowers should be:
And Priests in black gowns, were walking their
 rounds,
And binding with briars, my joys & desires.

Besides these songs two other works of Blake's poetry and painting have come under our notice, of which, however, we must confess our inability to give a sufficient account. These are two quarto volumes which appeared in 1794, printed and adorned like the Songs, under the titles of Europe, a Prophecy, and America, a Prophecy. The very 'Prophecies of Bakis' are not obscurer. 'America' appears in part to give a poetical account of the Revolution, since it contains the names of several party leaders. The actors in it are a species of guardian angels. We give

Opposite: First page of text of America, a Prophecy, *written in 1793, printed in 1795. This is from copy A, which was bought from Blake by the painter George Romney; it later belonged to the critic Isaac D'Israeli*

A PROPHECY

The Guardian Prince of Albion burns in his nightly tent.
Sullen fires across the Atlantic glow to America's shore:
Piercing the souls of warlike men, who rise in silent night,
Washington, Franklin, Paine & Warren, Gates, Hancock & Green;
Meet on the coast glowing with blood from Albions fiery Prince.

Washington spoke; Friends of America look over the Atlantic sea;
A bended bow is lifted in heaven, & a heavy iron chain
Descends link by link from Albions cliffs across the sea to bind
Brothers & sons of America, till our faces pale and yellow;
Heads deprest, voices weak, eyes downcast, hands work-bruis'd,
Feet bleeding on the sultry sands, and the furrows of the whip
Descend to generations that in future times forget.————

The strong voice ceas'd; for a terrible blast swept over the heaving sea
The eastern cloud rent; on his cliffs stood Albions wrathful Prince
A dragon form clashing his scales at midnight he arose,
And flam'd red meteors round the land of Albion beneath
His voice, his locks, his awful shoulders, and his glowing eyes,

Thus wept the Angel voice & as he wept the terrible blasts
Of trumpets, blew a loud alarm across the Atlantic deep.
No trumpets answer; no reply of clarions or of fifes,
Silent the Colonies remain and refuse the loud alarm.

On those vast shady hills between America & Albions shore;
Now barrd out by the Atlantic sea: calld Atlantean hills;
Because from their bright summits you may pass to the Golden world
An ancient palace, archetype of mighty Emperies,
Rears its immortal pinnacles, built in the forest of God
By Ariston the king of beauty for his stolen bride.

Here on their magic seats the thirteen Angels sat perturb'd
For clouds from the Atlantic hover oer the solemn roof.

only a short example, nor can we decide whether it is intended to be in prose or verse.

> On these vast shady hills between America's and
> Albion's shore,
> Now barred out by the Atlantic Sea: called Atlantean
> hills,
> Because from their bright summits you may pass to the
> golden world,
> An ancient palace, archetype of mighty empiries,
> Rears its immortal summit, built in the forests of God,
> By Ariston the King of Heaven for his stolen bride.

The obscurity of these lines in such a poem by such a man will be willingly overlooked.

'Europe' is a similar mysterious and incomprehensible rhapsody, which probably contains the artist's political visions of the future, but is wholly inexplicable. It appears to be in verse, and these are the first four lines:—

> I wrap my turban of thick clouds around my lab'ring
> head,

Opposite: Plate 10 from America, a Prophecy, *written 1793. This is from a copy printed c. 1807, that later belonged to the critic Richard Monkton Milnes, Lord Houghton*

PRELUDIUM

The nameless shadowy female rose from out the breast of Orc:
Her snaky hair brandishing in the winds of Enitharmon;
And thus her voice arose.

O mother Enitharmon wilt thou bring forth other sons?
To cause my name to vanish, that my place may not be found.
For I am faint with travel!
Like the dark cloud disburdend in the day of dismal thunder.

My roots are brandish'd in the heavens. my fruits in earth beneath
Surge, foam, and labour into life, first born & first consum'd!
Consumed and consuming!
Then why shouldst thou accursed mother bring me into life?

I wrap my turban of thick clouds around my lab'ring head;
And fold the sheety waters as a mantle round my limbs.
Yet the red sun and moon,
And all the overflowing stars rain down prolific pains.

And fold the sheety waters as a mantle round my limbs;
Yet the red Sun and Moon,
And all the overflowing stars rain down prolific pains.*

These Prophecies, like the Songs, appear never to
have come within the ken of the wider public.

We have now given an account of all the works of
this extraordinary man that have come under our
notice. We have been lengthy, but our object is to
draw the attention of Germany to a man in whom
all the elements of greatness are unquestionably to be
found, even though those elements are disproportion-
ately mingled. Closer research than was permitted us
would perhaps shew that as an artist Blake will never
produce consummate and immortal work, as a poet
flawless poems; but this assuredly cannot lessen the
interest which all men, Germans in a higher degree
even than Englishmen, must take in the contempla-
tion of such a character. We will only recall the phrase
of a thoughtful writer, that those faces are the most

* In fact these are lines 12-15 of the Preludium (ill. opposite)

Opposite: 'Preludium' from Europe, a Prophecy, *written in 1794, printed in
1795. This sheet from copy A may have been coloured mainly by Blake's wife
Catherine. It is possibly the copy bought by the painter George Romney. c. 1795*

attractive in which nature has set something of great-
ness which she has yet left unfinished; the same may
hold good of the soul.

JOHN THOMAS SMITH

Biographical Sketch of Blake

1828

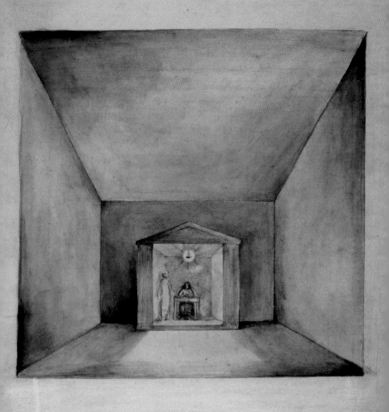

I believe it has been invariably the custom of every age, whenever a man has been found to depart from the usual mode of thinking, to consider him of deranged intellect, and not unfrequently stark staring mad; which judgment his calumniators would pronounce with as little hesitation, as some of the uncharitable part of mankind would pass sentence of death upon a poor half-drowned cur who had lost his master, or one who had escaped hanging with a rope about his neck. Cowper, in a letter to Lady Hesketh, dated June 3, 1788, speaking of a dancing-master's advertisement, says, 'The author of it had the good hap to be crazed, or he had never produced anything half so clever; for you will ever observe, that they who are said to have lost their wits, have more than other people."

Bearing this stigma of eccentricity, William Blake, with most extraordinary zeal, commenced his efforts in Art under the roof of No. 28 Broad-street, Carnaby Market; in which house he was born, and where his father carried on the business of a hosier. William, the subject of the following pages, who was his second

Opposite: A vision: the inspiration of the poet (Elisha in the Chamber on the Wall) c. 1819. Inscribed by his follower Frederick Tatham 'I suppose it to be a Vision... Indeed I remember a conversation with Mrs. Blake about it'

son, showing an early stretch of mind, and a strong talent for drawing, being totally destitute of the dexterity of a London shopman, so well described by Dr. Johnson, was sent away from the counter as a booby, and placed under the late Mr. James Basire, an Artist well known for many years as Engraver to the Society of Antiquaries. From him he learned the mechanical part of his art, and as he drew carefully, and copied faithfully, his master frequently and confidently employed him to make drawings from monuments to be engraven.

After leaving his instructor, in whose house he had conducted himself with the strictest propriety, he became acquainted with Flaxman, the Sculptor, through his friend Stothard, and was also honoured by an introduction to the accomplished Mrs. Mathew, whose house, No. 27, in Rathbone Place, was then frequented by most of the literary and talented people of the day. This lady—to whom I also had the honour of being known, and whose door and purse were constantly open and ready to cherish persons of genius who stood in need of assistance in their learned and arduous pursuits, worldly concerns, or inconveniences—was so extremely zealous in promoting the celebrity of Blake, that upon hearing him read some of his early efforts in poetry, she thought so well of them,

as to request the Rev Henry Mathew, her husband, to join Mr Flaxman in his truly kind offer of defraying the expense of printing them; in which he not only acquiesced, but, with his usual urbanity, wrote the following advertisement, which precedes the poems:

> The following sketches were the production of an untutored youth, commenced in his twelfth, and occasionally resumed by the author till his twentieth year; since which time, his talents having been wholly directed to the attainment of excellence in his profession, he has been deprived of the leisure requisite to such a revisal of these sheets, as might have rendered them less unfit to meet the public eye.
>
> Conscious of the irregularities aad defects to be found in almost every page, his friends have still believed that they possessed a poetical originality, which merited some respite from oblivion. These, their opinions, remain, however, to be now reproved or confirmed by a less partial public.

The annexed Song is a specimen of the juvenile playfulness of Blake's muse, copied from page 10 of these Poems.*

* The whole copy of this little work, entitled 'Poetical Sketches, by W. B.' containing seventy pages, octavo, bearing the date 1783, was given to Blake to sell to friends, or publish, as he might think proper.

SONG.

How sweet I roam'd from field to field,
And tasted all the Summer's pride,
Till I the Prince of Love beheld,
Who in the sunny beams did glide!

He show'd me lilies for my hair,
And blushing roses for my brow;
He led me through his gardens fair,
Where all his golden pleasures grow.

With sweet May-dews my wings were wet,
And Phœbus fired my vocal rage;
He caught me in his silken net,
And shut me in his golden cage.

He loves to sit and hear me sing,
Then, laughing, sports and plays with me;
Then stretches out my golden wing,
And mocks my loss of liberty.'

But it happened, unfortunately, soon after this period,
that in consequence of his unbending deportment, or
what his adherents are pleased to call his manly firm-
ness of opinion, which certainly was not at all times
considered pleasing by every one, his visits were not
so frequent. He however continued to benefit by Mrs.
Mathew's liberality, and was enabled to continue in

partnership, as a Printseller, with his fellow-pupil, Parker, in a shop, No. 27, next door to his father's, in Broad-street; and being extremely partial to Robert, his youngest brother, considered him as his pupil. Bob, as he was familiarly called, was one of my playfellows, and much beloved by all his companions.

Much about this time, Blake wrote many other songs, to which he also composed tunes. These he would occasionally sing to his friends; and though, according to his confession, he was entirely unacquainted with the science of music, his ear was so good, that his tunes were sometimes most singularly beautiful, and were noted down by musical professors. As for his later poetry, if it may be so called, attached to his plates, though it was certainly in some parts enigmatically curious as to its application, yet it was not always wholly uninteresting; and I have unspeakable pleasure in being able to state, that though I admit he did not for the last forty years attend any place of Divine worship, yet he was not a Freethinker, as some invidious detractors have thought proper to assert, nor was he ever in any degree irreligious. Through life, his Bible was everything with him; and as a convincing proof how highly he reverenced the Almighty, I shall introduce the following lines with which he concludes his address to the Deists:

Eve tempted by the Servant
c. 1799-1800

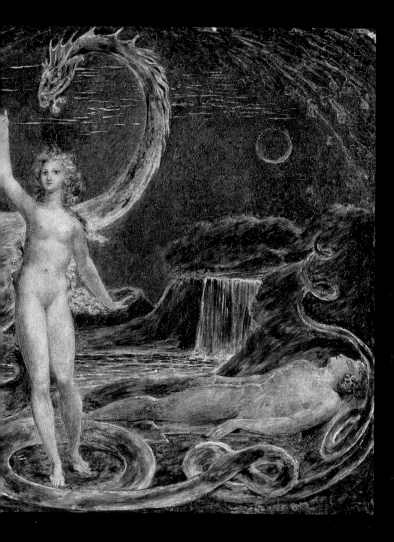

> For a tear is an intellectual thing;
> And a sigh is the sword of an Angel-King;
> And the bitter groan of a Martyr's woe
> Is an arrow from the Almighty's bow.[1]

Again, at page 77, in his address to the Christians:

> I give you the end of a golden string;
> Only wind it into a ball,
> It will lead you in at Heaven's gate.
> Built in Jerusalem's wall.[2]

In his choice of subjects, and in his designs in Art, perhaps no man had higher claim to originality, nor ever drew with a closer adherence to his own conception; and from what I knew of him, and have heard related by his friends, I most firmly believe few artists have been guilty of less plagiarisms than he. It is true, I have seen him admire and heard him expatiate upon the beauties of Marc Antonio [Raimondi] and of Albert Dürer; but I verily believe not with any view of borrowing an idea; neither do I consider him at any time dependent in his mode of working, which was generally with the graver only; and as to printing, he mostly took off his own impressions.

1. *Jerusalem*, plate 52. 2. *Jerusalem*, plate 77.

After his marriage, which took place at Battersea, and which proved a mutually happy one, he instructed his *beloved*, for so he most frequently called his Kate,* and allowed her, till the last moment of his practice, to take off his proof impressions and print his works, which she did most carefully, and ever delighted in the task: nay, she became a draughtswoman; and as a convincing proof that she and her husband were born for each other's comfort, she not only entered cheerfully into his views, but, what is curious, possessed a similar power of imbibing ideas, and has produced drawings equally original, and, in some respects, interesting.

Blake's peace of mind, as well as that of his Catherine, was much broken by the death of their brother Robert, who was a most amicable link in their happiness; and, as a proof how much Blake respected him, whenever he beheld him in his visions, he implicitly

* A friend has favoured me with the following anecdotes, which he received from Blake, respecting his courtship. He states that 'Our Artist fell in love with a lively little girl, who allowed him to say everything that was loving, but would not listen to his overtures on the score of matrimony. He was lamenting this in the house of a friend, when a generous-hearted lass declared that she pitied him from her heart. 'Do you pity me?' asked Blake. 'Yes; I do, most sincerely.'— 'Then,' said he, 'I love you for that.'—'Well,' said the honest girl, 'and I love you.' The consequence was, they were married, and lived the happiest of lives.

attended to his opinion and advice as to his future projected works. I should have stated, that Blake was supereminently endowed with the power of disuniting all other thoughts from his mind, whenever he wished to indulge in thinking of any particular subject; and so firmly did he believe, by this abstracting power, that the objects of his compositions were before him in his mind's eye, that he frequently believed them to be speaking to him. This I shall now illustrate by the following narrative.

Blake, after deeply perplexing himself as to the mode of accomplishing the publication of his illustrated songs, without their being subject to the expense of letter-press, his brother Robert stood before him in one of his visionary imaginations, and so decidedly directed him in the way in which he ought to proceed, that he immediately followed his advice, by writing his poetry, and drawing his marginal subjects of embellishments in outline upon the copper-plate with an impervious liquid, and then eating the plain parts or lights away with aquafortis considerably below them, so that the outlines were left as a stereotype. The plates in this state were then printed in any tint

Opposite: Blake's brother Robert, from Milton a poem, *composed c. 1804-11, this copy printed 1818*

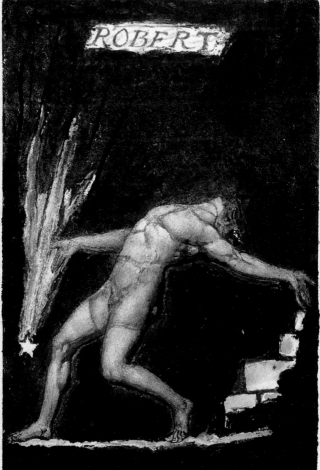

ROBERT

that he wished, to enable him or Mrs. Blake to colour the marginal figures up by hand in imitation of drawings.

The following are some of his works produced in this manner, viz.; 'Songs of Innocence and Songs of Experience,' 'The Book of Jerusalem,' consisting of an hundred plates, 'The Marriage of Heaven and Hell,' 'Europe' and 'America'; and another work, which is now very uncommon, a pretty little series of plates, entitled 'Gate of Paradise.'

Blake, like those artists absorbed in a beloved study, cared not for money beyond its use for the ensuing day; and indeed he and his 'beloved' were so reciprocally frugal in their expenses, that, never sighing for either gilded vessels, silver-laced attendants, or turtle's livers, they were contented with the simplest repast, and a little answered their purpose. Yet, notwithstanding all their economy, Dame Fortune being, as it is pretty well known to the world, sometimes a fickle jade, they, as well as thousands more, have had their intercepting clouds.

As it is not my intention to follow them through their lives, I shall confine myself to a relation of a few other anecdotes of this happy pair; and as they are

Opposite: Plate 21 from The Marriage of Heaven and Hell, *composed c. 1790, this copy printed c. 1795, possibly for the painter George Romney*

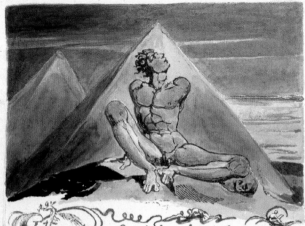

I have always found that Angels have the vani-
ty to speak of themselves as the only wise; this they
do with a confident insolence sprouting from systema-
tic reasoning:

Thus Swedenborg boasts that what he writes is
new; tho' it is only the Contents or Index of Already
publish'd books

A man carried a monkey about for a shew, & be-
cause he was a little wiser than the monkey, grew
vain, and conciev'd himself as much wiser than se-
ven men. It is so with Swedenborg; he shews the
folly of churches & exposes hypocrites, till he im-
agines that all are religious. & himself the single
one

He looks on *Time*, as nothing. Nothing else
Is truly Man's; 'tis Fortune's.----Time's a God.
Thou haft ne'er heard of *Time's* Omnipotence;
For, or *against*, what Wonders can He do?
And *will*: To stand blank *Neuter* He disdains.
Not on *those terms* was *Time*, (Heaven's Stranger!) sent
On his important Embassy to Man.
Lorenzo! no: On the long-destin'd Hour,
From everlasting Ages growing ripe, 210
That memorable Hour of wond'rous Birth,
When the Dread Sire, on Emanation bent,
And big with Nature, rising in his might,
Call'd forth Creation, (for then *Time* was born)
By Godhead streaming thro' a thousand Worlds,
Not on *those Terms*, from the great days of Heaven,
From old Eternity's mysterious Orb,
Was *Time* cut off, and cast beneath the Skies;
The Skies, which watch him in his new abode,
Measuring his Motions by revolving Spheres; 220
That Horologe Machinery Divine.

I Hours,

connected with the Arts, in my opinion they ought not to be lost, as they may be considered worthy the attention of future biographers.

For his marginal illustrations of Young's 'Night Thoughts,' which possess a great power of imagination, he received so despicably low a price, that Flaxman, whose heart was ever warm, was determined to serve him whenever an opportunity offered itself; and with his usual voice of sympathy, introduced him to his friend Hayley, with whom it was no new thing to give pleasure, capricious as he was. This gentleman immediately engaged him to engrave the plates for his quarto edition of 'The Life of Cowper,' published in 1803-4; and for this purpose he went down to Felpham, in order to be near that highly respected *Hermit*.

Here he took a cottage, for which he paid twenty pounds a-year, and was not, as has been reported, entertained in a house belonging to Mr. Hayley, rent-free. During his stay he drew several portraits, and could have had full employment in that department of the Art; but he was born to follow his own inclinations, and was willing to rely upon a reward for the labours of the day.

Opposite: Watercolour illustration to Edward Young's Night Thoughts, *'Night the Second', page 16, c. 1795-7*

When on the highest lift of his light pinions he arrives
At that bright Gate, another Lark meets him & back to back
They touch their pinions tip tip: and each descend
To their respective Earths & there all night consult with Angels
Of Providence & with the Eyes of God all night in slumbers
Inspired: & at the dawn of day send out another Lark
Into another Heaven to carry news upon his wings
Thus are the Messengers dispatchd till they reach the Earth again
In the East Gate of Golgonooza, & the Twenty-eighth bright
Lark, met the Female Ololon descending into my Garden
Thus it appears to Mortal eyes & those of the Ulro Heavens
But not thus to Immortals, the Lark is a mighty Angel.

For Ololon step'd into the Polypus within the Mundane Shell
They could not step into Vegetable Worlds without becoming
The enemies of Humanity except in a Female Form
And as One Female, Ololon and all its mighty Hosts
Appear'd: a Virgin of twelve years nor time nor space was
To the perception of the Virgin Ololon but as the
Flash of lightning but more quick the Virgin in my Garden
Before my Cottage stood for the Satanic Space is delusion

For when Los joind with me he took me in his firy whirlwind
My Vegetated portion was hurried from Lambeths shades
He set me down in Felphams Vale & prepard a beautiful
Cottage for me that in three years I might write all these
Visions
To display Natures cruel holiness: the deceits of Natural
Religion
Walking in my Cottage Garden, sudden I beheld
The Virgin Ololon & addressd her as a Daughter of Beulah
Virgin of Providence fear not to enter into my Cottage
What is thy message to thy friend: what am I now to do
Is it again to plunge into deeper affliction? behold me
Ready to obey, but pity thou my Shadow of Delight
Enter my Cottage, comfort her, for she is sick with fatigue

Mr. Flaxman, knowing me to be a collector of autographs, among many others, gave me the following letter, which he received from Blake immediately after his arrival at Felpham, in which he styles him

Dear Sculptor of Eternity,

We are safe arrived at our cottage, which is more beautiful than I thought it, and more convenient. It is a perfect model for cottages, and, I think, for palaces of magnificence; only enlarging, not altering, its proportions, and adding ornaments, and not principals. Nothing can be more grand than its simplicity and usefulness. Simple without intricacy, it seems to be the spontaneous effusion of humanity, congenial to the wants of man. No other-formed house can ever please me so well; nor shall I ever be persuaded, I believe, that it can be improved either in beauty, or use.

Mr. Hayley received us with his usual brotherly affection. I have begun to work. Felpham is a sweet place for study, because it is more spiritual than London. Heaven opens here on all sides her golden gates; her windows are not obstructed by vapours; voices of celestial inhabitants are more distinctly heard, and their forms more distinctly seen, and my

Opposite: Blake's cottage at Felpham: plate 36 of Milton a poem *written c. 1804-11, this copy printed c. 1818*

cottage is also a shadow of their houses. My wife and sister are both well, courting Neptune for an embrace.

Our journey was very pleasant; and though we had a great deal of luggage, no grumbling. All was cheerfulness and good-humour on the road, and yet we could not arrive at our cottage before half-past eleven at night, owing to the necessary shifting of our luggage from one chaise to another; for we had seven different chaises, and as many different drivers. We set out between six and seven in the morning of Thursday, with sixteen heavy boxes, and portfolios full of prints.

And now begins a new life, because another covering of earth is shaken off. I am more famed in Heaven for my works than I could well conceive. In my brain, are studies and chambers filled with books and pictures of old, which I wrote and painted in ages of eternity, before my mortal life; and those works are the delight and study of archangels. Why then should I be anxious about the riches or fame of mortality? The Lord, our father, will do for us and with us according to his Divine will for our good.

You, O dear Flaxman! are a sublime Archangel,

Opposite: The Horse, c. 1805, tempera painting after illustration prepared for Hayley's Ballads in 1802, which Blake described as 'one of my best — I know it has cost me immense labour'.

my friend and companion from eternity. In the Divine bosom is our dwelling-place. I look back into the regions of reminiscence and behold our ancient days before this earth appeared in its vegetated mortality to my mortal-vegetated eyes. I see our houses of eternity which can never be separated, though our mortal vehicles should stand at the remotest corners of Heaven from each other.

Farewell, my best friend! Remember me and my wife in love and friendship to our dear Mrs. Flaxman, whom we ardently desire to entertain beneath our thatched roof of rusted gold; and believe me for ever to remain,

<div align="center">Your grateful and affectionate,

William Blake.

Felpham, *Sept.* 21st, 1800. Sunday morning.</div>

In a copy of Hayley's 'Triumphs of Temper,' illustrated by Stothard, which had been the one belonging to the Author's son, and which he gave after his death to Blake, are these verses in MS. by the hand of the donor.

Accept, my gentle visionary, Blake,
Whose thoughts are fanciful and kindly mild;
Accept, and fondly keep for friendship's sake,
This favoured vision, my poetic child.
'Rich in more grace than fancy ever won.

To thy most tender mind this book will be,
For it belonged to my departed son;
So from an angel it descends to thee.
 W. H. *July*, 1800.

Upon his return from Felpham, he addressed the public, in page 3 of his Book of Jerusalem, in these words: 'After my three years' slumber on the banks of the ocean, I again display my giant-forms to the public,' etc.

Some of the 'giant-forms,' as he calls them, are mighty and grand, and if I were to compare them to the style of any preceding artist, Michel Angelo, Sir Joshua's favourite, would be the one; and were I to select a specimen as a corroboration of this opinion, I should instance the figure personifying the 'Ancient of Days,' the frontispiece to his 'Europe, a Prophecy.'* In my mind, his knowledge of drawing, as well as design, displayed in this figure, must at once convince the informed reader of his extraordinary abilities.

I am now under the painful necessity of relating an event promulgated in two different ways by two different parties; and as I entertain a high respect for the talents of both persons concerned, I shall, in order to steer clear of giving umbrage to the supporters of

* See ill. p. 4

either, leave the reader to draw his own conclusions, unbiassed by any insinuation whatever of mine.

An Engraver of the name of Cromek, a man who endeavoured to live by speculating upon the talents of others, purchased a series of drawings of Blake, illustrative of Blair's 'Grave,' which he had begun with a view of engraving and publishing. These were sold to Mr. Cromek for the insignificant sum of one guinea each, with the promise, and indeed under the express agreement, that Blake should be employed to engrave them; a task to which he looked forward with anxious delight. Instead of this negotiation being carried into effect, the drawings, to his great mortification, were put, into the hands of Schiavonetti. During the time this artist was thus employed, Cromek had asked Blake what work he had in mind to execute next. The unsuspecting artist not only told him, but without the least reserve showed him the designs sketched out for a fresco picture; the subject Chaucer's 'Pilgrimage to Canterbury'; with which Mr. Cromek appeared highly delighted. Shortly after this, Blake discovered that Stothard, a brother-artist to whom he had been extremely kind in early days, had been employed to paint a picture, not only of the same subject, but in some instances similar to the fresco sketch which he had shown to Mr. Cromek. The picture painted by

Stothard became the property of Mr. Cromek, who published proposals for an engraving from it, naming Bromley as the engraver to be employed. However, in a short time, that artist's name was withdrawn, and Schiavonetti's substituted, who lived only to complete the etching; the plate being finished afterwards by at least three different hands. Blake, highly indignant at this treatment, immediately set to work, and proposed an engraving from his fresco picture, which he publicly exhibited in his brother James's shop-window, at the corner of Broad Street, accompanied with an address to the public, stating what he considered to be improper conduct. So much on the side of Blake.* On the part of Stothard, the story runs thus. Mr. Cromek had agreed with that artist to employ him upon a picture of the Procession of Chaucer's Pilgrimage to Canterbury, for which he first agreed to pay him sixty guineas, but in order to enable him to finish it in

* In 1809, Blake exhibited sixteen poetical and historical inventions, in his brother's first-floor in Broad-street; eleven pictures in fresco, professed to be painted according to the ancient method, and seven drawings, of which an explanatory catalogue was published, and is perhaps the most curious of its kind ever written. At page 7, the description of his fresco-painting of Geoffrey Chaucer's Pilgrimage commences. This picture, which is larger than the print, is now in the possession of Thomas Butts, Esq. a gentleman friendly to Blake, and who is in possession of a considerable number of his works.

a move exquisite manner, promised him forty more, with an intention of engaging Bromley to engrave it; but in consequence of some occurrence, his name was withdrawn, and Schiavonetti was employed. during the time Stothard was painting the picture, Blake called to see it, and appeared so delighted with it, that Stothard, sincerely wishing to please an old friend with whom he had lived so cordially for many years, and from whose works he always most liberally declared he had received much pleasure and edification, expressed a wish to introduce his portrait as one of the party, as a mark of esteem.

Mr. Hoppner, in a letter to a friend, dated May 30th, 1807, says of it,

> This intelligent group is rendered still more interesting by the charm of colouring, which though simple is strong, and most harmoniously distributed throughout the picture. The landscape has a deep-toned brightness that accords most admirably with the figures; and the painter has ingeniously contrived to give a value to a common scene and very ordinary forms, that would hardly be found, by unlearned eyes, in the natural objects. He has expressed too, with great vivacity and truth, the freshness of morning, at that season when Nature herself is most fresh and blooming—the Spring;

and it requires no great stretch of fancy to imagine we perceive the influence of it on the cheeks of the Fair Wife of Bath, and her rosy companions, the Monk and Friar.

In respect of the execution of the various parts of this pleasing design, it is not too much praise to say, that it is wholly free from that vice which painters term *manner*; and it has this peculiarity beside which I do not remember to have seen in any picture, ancient or modern, namely, that it bears no mark of the period in which it was painted, but might very well pass for the work of some able artist of the time of Chaucer. This effect is not, I believe, the result of any association of ideas connected with the costume, but appears in primitive simplicity, and the total absence of all affectation, either of colour or pencilling.

Having attempted to describe a few of the beauties of this captivating performance, it remains only for me to mention one great defect The picture is, notwithstanding appearances, *a modern one*. But if you can divest yourself of the general prejudice that exists against contemporary talents, you will see a work that would have done honour to any school, at any period.

In 1810, Stothard, to his great surprise, found that Blake had engraved and published a plate of the

same size, in some respects bearing a similarity to his own.* Such are the outlines of this controversy.

Blake's ideas were often truly entertaining, and after he had conveyed them to paper, his whimsical and novel descriptions frequently surpassed his delineations; for instance, that of his picture of the Transformation of the Flea to the form of a Man, is extremely curious. This personification, which he denominated a Cupper, or Blood-sucker, is covered with coat of armour, similar to the case of the flea, and is represented slowly

* I must do Mr. Stothard the justice to declare, that the very first time I saw him after he had read the announcement of Blake's death, he spoke in the handsomest terms of his talents, and informed me that Blake made a remarkably correct and fine drawing of the head of Queen Philippa, from her monumental effigy in Westminster Abbey, for Gough's Sepulchral Monuments, engraved by Basire. The collectors of Stothard's numerous and elegant designs, will recollect the name of Blake as the engraver of several plates in the Novelist's Magazine, the Poetical Magazine, and also others for a work entitled the Wit's Magazine, from drawings produced by the same artist. Trotter, the engraver, who received instructions from Blake, and who was a pattern-draughtsman to the calico-printers, introduced his friend Stothard to Blake, and their attachment for each other continued most cordially to exist in the opinion of the public, until they produced their rival pictures of Chaucer's Canterbury Pilgrimage.

Opposite: Frontispiece to prospectus published by Blake in 1809 to advertise his engraving of Chaucer's Canterbury Pilgrims, *with detail from left of full engraving, showing Chaucer second from left.*

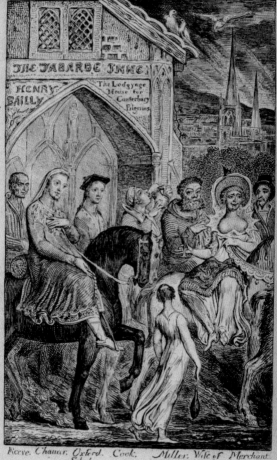

THE TABARDE INNE

HENRY BAILLY

The Lodgyage House for Canterbury Pilgrims

Reeve. Chaucer. Oxford. Cook. Miller. Wife of Bath. Merchant

Publish'd Dec.ʳ 26 1811 by Newbery 5 Pauls Ch. Yard

W Blake inv & sc

pacing in the night, with a thorn attached to his right hand, and a cup in the other, as if ready to puncture the first person whose blood he might fancy, like Satan prowling about to seek whom he could devour. Blake said of the flea, that were that lively little fellow the size of an elephant, he was quite sure, from the calculations he had made of his wonderful strength, that he could bound from Dover to Calais in one leap.* Whatever may be the public opinion hereafter of Blake's talents, when his enemies are dead, I will not presume to predict;† but this I am certain of, that on the score of industry at least, many artists must strike to him. Application was a faculty so gendered in him that he took

* This interesting little picture is painted in fresco. It is now the property of John Varley, the artist, whose landscapes will ever be esteemed as some of the finest productions in Art, and who may fairly be considered as one of the founders of the Society of Artists in Water Colours; the annual exhibitions of which continue to surpass those of the preceding seasons. [see ill. p . 118]

† Blake's talent is not to be seen in his engravings from the designs of other artists, though he certainly honestly endeavoured to copy the beauties of Stothard, Flaxman, and those masters set before him by the few publishers who employed him; but his own engravings from his own mind are the productions which the man of true feeling must ever admire, and the predictions of Fuseli and Flaxman may hereafter be verified—'That a time will come when Blake's finest works will be as much sought after and treasured up in the portfolios of men of mind, as those of Michel Angelo are at present.'

little bodily exercise to keep up his health: he had few evening walks and little rest from labour, for his mind was ever fixed upon his art, nor did he at any time indulge in a game of chess, draughts, or backgammon; such amusements, considered as relaxations by artists in general, being to him distractions. His greatest pleasure was derived from the Bible,—a work ever at his hand, and which he often assiduously consulted in several languages. Had he fortunately lived till the next year's exhibition at Somerset-house, the public would then have been astonished at his exquisite inishing of a Fresco picture of the Last Judgment, containing upwards of one thousand figures, many of them wonderfully conceived and grandly drawn. The lights of this extraordinary performance have the appearance of silver and gold; but upon Mrs. Blake's assuring me that there was no silver used, I found, upon a closer examination, that a blue wash had been passed over those parts of the gilding which receded, and the lights of the forward objects, which were also of gold, were heightened with a warm colour, to give the appearance of the two metals.

It is most certain, that the uninitiated eye was incapable of selecting the beauties of Blake; his effusions were not generally felt; and in this opinion I am borne out in the frequent assertions of Fuseli and Flaxman.

It would, therefore, be unreasonable to expect the book-sellers to embark in publications not likely to meet remuneration. Circumstanced, then, as Blake was, approaching to threescore years and ten, in what way was he to persevere in his labours? Alas, he knew not! until the liberality of Mr. Linnell, a brother-artist of eminence, whose discernment could well appreciate those parts of his designs which deserved perpetuity, enabled him to proceed and execute in comfort a series of twenty-one plates, illustrative of the Book of Job. This was the last work he completed, upon the merits of which he received the highest congratulations from the following Royal Academicians: Sir Thomas Lawrence, Mr. Baily, Mr. Philips, Mr. Chantrey, Mr. James Ward, Mr. Arnald, Mr. Collins, Mr. Westmacott, and many other artists of eminence.

As to Blake's system of colouring, which I have not hitherto noticed, it was in many instances most beautifully prismatic. In this branch of the art he often acknowledged Apelles to have been his tutor, who was, he said, so much pleased with his style, that once when he appeared before him, among many of his observations, he delivered the following:—'You certainly possess my system of colouring; and I now wish you to draw my person, which has hitherto been untruly delineated.'

I must own that, until I was favoured by Mr. Up-
cott with a sight of some, of Blake's works, several of
which I had never seen, I was not so fully aware of
his great depth of knowledge in colouring. Of these
most interesting specimens of his art, which are now
extremely rare, and rendered invaluable by his death,
as it is impossible for any one to colour them with his
mind, should the plates remain, Mr. Richard Thom-
son, another truly kind friend, has favoured me with
the following descriptive lists.

> *Songs of Experience.* The author and printer, W. Blake.
> Small octavo; seventeen plates, including the title-
> page. Frontispiece, a winged infant mounted on the
> shoulders of a youth. On the title-page, two figures
> weeping over two crosses.
> Introduction. *Four Stanzas on a cloud, with a night-sky
> behind, and beneath, a figure of Earth stretched on a mantle.*
> *Earth's Answer,* Five Stanzas. A serpent on the
> ground beneath.
> *The Clod and the Pebble.* Three Stanzas. Above, a
> head-piece of four sheep and two oxen; beneath, a
> duck and reptiles.
> *A Poison Tree.* Four Stanzas. The tree stretcher up the
> right side of the page; and beneath, a dead body
> killed by its influence.
> *The Fly.* Five Stanzas. Beneath, a female figure with
> two children.

Holy Thursday. Four Stanzas. Head-piece, a female figure discovering a dead child. On the right-hand margin a mother and two children lamenting the loss of an infant which lies beneath. Perhaps this is one of the most tasteful of the set. *The Chimney-Sweeper.* Three Stanzas. Beneath, a figure of one walking in snow towards an open door.

London. Four Stanzas. Above, a child leading an old man through the street; on the right-hand, a figure warming itself at a fire. If in any instance Mr. Blake has copied himself, it is in the figure of the old man upon this plate, whose position appears to have been a favourite one with him.

The Tiger. Six Stanzas. On the right-hand margin, the trunk of a tree; and beneath, a tiger walking.

A Little Boy Lost. Six Stanzas. Ivy-leaves on the right-hand, and beneath, weeping figures before a fire, in which the verses state that the child had been burned by a Saint.

The Human Abstract. Six Stanzas. The trunk of a tree on the right-hand margin, and beneath, an old man in white drawing a veil over his head.

The Angel. Four Stanzas. Head-piece, a female figure lying beneath a tree, and pushing from her a winged boy.

My Pretty Rose Tree. Two Stanzas: succeeded by a small vignette, of a figure weeping, and another

Opposite: The Little Boy lost, from Songs of Innocence and of Experi-ence, *1789-94, in a copy belonging to the artist and poet George Cumberland*

The Little Boy lost

Father, father where are you going
O do not walk so fast,
Speak father, speak to your little boy
Or else I shall be lost,

The night was dark no father was there
The child was wet with dew,
The mire was deep, & the child did weep
And away the vapour flew.

What time the thirteen Governors that England sent
In Bernards house; the flames coverd the land, they rouze
they cry
Shaking their mental chains they rush in fury to the sea
To quench their anguish; at the feet of Washington down
They grovel on the sand and writhing lie, while all
The British soldiers thro' the thirteen states sent up a
Of anguish: threw their swords & muskets to the earth &
From their encampments and dark castles seeking where
From the grim flames; and from the visions of Orc; in
Of Albions Angel; who enraged his secret clouds opend
From north to south, and burnt outstretchd on wings of wrath
The eastern sky, spreading his awful wings acrids the heav
Beneath him rolld his numrous hosts, all Albions Angels
Darkend the Atlantic mountains & their trumpets shook
Armd with diseases of the earth to cast upon the Abyss;
Their numbers forty millions, mustring in the eastern sky

lying reclined at the foot of a tree. Beneath, are two verses more, entitled. *Ah! Sun Flower;* and a single Stanza, headed *The Lily*.

Nurses Song. Two Stanzas. Beneath, a girl with a youth and a female child at a door surrounded by vine-leaves.

A Little Girl Lost. Seven Stanzas; interspersed with birds and leaves, the trunk of a tree on the right-hand margin.

The whole of these plates are coloured in imitation of fresco. The poetry of these songs is wild, irregular, and highly mystical, but of no great degree of elegance or excellence, and their prevailing feature is a tone of complaint of the misery of mankind.

America: a Prophecy. Lambeth; Printed by William Blake, in the year 1795; folio; eighteen plates or twenty pages, including the frontispiece and title-page. After a preludium of thirty-seven lines commences the Prophecy of 226, which are interspersed with numerous head-pieces, vignettes, and tail-pieces, usually stretching along the left-hand margin and enclosing the text; which sometimes appears written on a cloud, and at others environed by flames and water. Of the latter subject a very fine specimen is shown upon page 13, where the tail-piece represents the bottom of the sea, with various fishes coming together to prey upon a dead body. The head-piece

Opposite: Plate 13 from America a Prophecy, *composed 1793, printed c. 1807*

is another dead body lying on the surface of the waters, with an eagle feeding upon it with outstretched wings. Another instance of Mr. Blake's favourite figure of the old man entering at Death's door, is contained on page 12 of this poem. The subject of the text is a conversation between the Angel of Albion, the Angels of the Thirteen States, Washington, and some others of the American Generals, and 'Red Orc,' the spirit of war and evil. The verses are without rhyme, and most resemble hexameters, though they are by no means exact; and the expressions are mystical in a very high degree.

Europe: a Prophecy. Lambeth; Printed by William Blake, 1794; folio; seventeen plates on the leaves, inclusive of the frontispiece and title-page. Coloured to imitate the ancient fresco-painting. The Preludium consists of thirty-three lines, in stanzas without rhyme, and the Prophecy of two hundred and eight; the decorations to which are larger than most of those in the former book, and approach nearest to the character of paintings, since, in several instances, they occupy the whole page. The frontispiece is an uncommonly fine specimen of art, and approaches almost to the sublimity of Raffaelle or Michel Angelo. It represents 'The Ancient of Days,'* in an orb of light surrounded by dark

* 'See ill. p. 4

Opposite: Plate 12 from America a Prophecy,
composed 1793, printed c. 1807

So cried he, rending off his robe & throwing down his scepter.
In sight of Albions Guardian, and all the thirteen Angels
Rent all their robes to the hungry wind, & threw their golden scep-
 ters
Down on the land of America, indignant they descended
Headlong from out their heavenly heights, descending swift as
 fires
Over the land: naked & flaming are their lineaments seen
In the deep gloom, by Washington & Paine & Warren they stood
And the flame folded roaring fierce within the pitchy nig:
Before the Demon red, who burnt towards America,
In black smoke thunders and loud winds rejoicing in its
 terror
Breaking in smoky wreaths from the wild deep, & gathring thick
In flames as of a furnace on the land from North to South

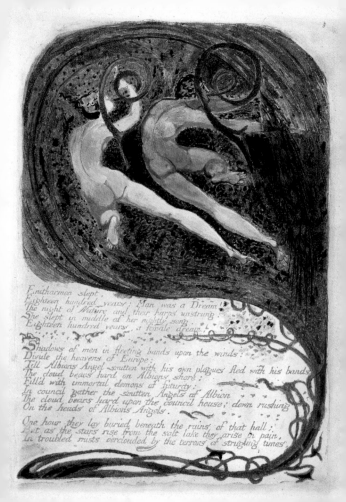

Enitharmon slept,
Eighteen hundred years: Man was a Dream!
The night of Nature and their harps unstrung:
She slept in middle of her nightly song,
Eighteen hundred years, a female dream.

Shadows of men in fleeting bands upon the winds:
Divide the heavens of Europe:
Till Albions Angel smitten with his own plagues fled with his bands
The cloud bears hard on Albions shore:
Fill'd with immortal demons of futurity:
In council gather the smitten Angels of Albion
The cloud bears hard upon the council house; down rushing
On the heads of Albions Angels

One hour they lay buried beneath the ruins of that hall;
But as the stars rise from the salt lake they arise in pain,
In troubled mists o'erclouded by the terrors of struggling times:

clouds, as referred to in Proverbs viii. 27, stooping down with an enormous pair of compasses to describe the destined orb of the world, 'when he set a compass upon the face of the earth.'

> 'in His hand
> He took the golden compasses, prepar'd
> In God's eternal store, to circumscribe
> This universe and all created things:
> One foot he centred, and the other turn'd
> Round through the vast profundity obscure;
> And said, "Thus far extend, thus far thy bounds.
> This be thy just circumference, O World!"'
>
> *Paradise Lost*, VII. 236.

Another splendid composition in this work, are. the two angels pouring out the black-spotted plague upon England, on page 9; in which the fore-shortening of the legs, the grandeur of their positions, and the harmony with which they are adapted to each other and to their curved trumpets, are perfectly admirable. The subject-matter of the work is written in the same wild and singular measures as the preceding, and describes, in mystical language, the terrors of plague and anarchy which overspread England during the slumbers of Enitharmon for eighteen hundred years; upon whose awaking, the ferocious spirit Orc bursts into flames "in the vineyards of red France." At the end of this poem are

Opposite: Plate 9 from Europe, a Prophecy, *composed and printed 1794*

seven separate engravings on folio pages, without letter-press, which are coloured like the former part of the work, with a degree of splendour and force, as almost to resemble sketches in oil-colours. The finest. of these are a figure of an angel standing in the sun, a group of three furies surrounded by clouds and fire, and a figure of a man sitting beneath a tree in the deepest dejection; all of which are peculiarly remarkable for their strength and splendour of colouring. Another publication by Mr. Blake, consisted only of a small quarto volume of twenty-three engravings of various shapes and sizes, coloured as before, some of which are of extraordinary effect and beauty. The best plates in this series are,—the first of an aged man, with a white beard sweeping the ground, and writing in a book with each hand, naked; a human figure pressing out his brain through his ears; and the great sea-serpent; but perhaps the best is a figure sinking in a stormy sea at sun-set, the splendid light of which, and the foam upon the black waves, are almost magical effects of colouring. Beneath the first design is engraven '*Lambeth, printed by W, Blake*, 1794.'[1]

Blake's modes of preparing his ground, and laying them over his panels for painting, mixing his colours, and manner of working, were those which

1. *A Small Book of Designs*, made for Ozias Humphry, 1796. See ills. pp 1, 28 and 187

he considered to have been practised by the earliest fresco-painters, whose productions still remain, in numerous instances, vivid and permanently fresh. His ground was a mixture of whiting and carpenter's glue which he passed over several times in thin coatings: his colours he ground himself, and also united them with the same sort of glue, but in a much weaker state. He would, in the course of painting a picture, pass a very thin transparent wash of glue-water over the whole of the parts he had worked upon, and then proceed with his finishing.*

* Loutherbourgh was also, in *his* way, very ingenious in his contrivances. To oblige his friend Garrick, he enriched a Drama, entitled '*The Christmas Tale,*' with scenery painted by himself, and introduced such novelty and brilliancy of effect, as formed a new era in that species of art. This he accomplished by means of differently coloured silks placed before the lamps at the front of the stage, and by the lights behind the side scenes. The same effects were used for distance and atmosphere. As for instance, Harlequin in a fog, was produced by tiffany hung between the audience and himself. Mr. Seguier, the father of the Keeper of the King's Pictures, and those of the National Gallery, purchased of Mr. Loutherbourgh ten small designs for the scenery of Omiah, for which scenes the manager paid him one thousand pounds. Mr. Loutherbourgh never would leave any paper or designs at the theatre, nor would he ever allow any one to see what he intended to produce; as he secretly held small cards in his hand, which he now and then referred to m order to assist him in his recollections of his small drawings.

This process I have tried, and find, by using my mixtures warm, that I can produce the same texture as possessed in Blake's pictures of the Last Judgment, and others of his productions, particularly in Varley's curious picture of the personified Flea. Blake preferred mixing his colours with carpenter's glue, to gum, on account of the latter cracking in the sun, and becoming humid in moist weather. The glue-mixture stands the sun, and change of atmosphere has no effect upon it. Every carpenter knows that if a broken piece of stick be joined with good glue, the stick will seldom break again in the glued parts.

That Blake had many secret modes of working, both as a colourist and an engraver, I have no doubt. His method of eating away the plain copper, and leaving his drawn lines of his subjects and his words as stereotype, is in my mind perfectly original. Mrs. Blake is in possession of the secret, and she ought to receive something considerable for its communication, as I am quite certain it may be used to the greatest advantage both to artists and literary characters in general.

That Blake's coloured plates have more effect than others where gum has been used, is, in my opinion, the fact, and I shall rest my assertion upon those beautiful specimens in the possession of Mr. Upcott, coloured purposely for that gentleman's godfather, Ozias

Humphry, Esq. to whom Blake wrote the following interesting letter.

TO OZIAS HUMPHRY, Esq.

The design of The Last Judgment, which I have completed by your recommendation for the Countess of Egremont, it is necessary to give some account of; and its various parts ought to be described, for the accommodation of those who give it the honour of their attention.*

Christ seated on the Throne of Judgment: the Heavens in clouds rolling before him and around him, like a scroll ready to be consumed in the fires of the Angels; who descend before his feet, with their four trumpets sounding to the four winds.

Beneath, the Earth is convulsed with the labours of the Resurrection. In the caverns of the earth is the Dragon with seven heads and ten horns, chained by two Angels; and above his cavern, on the earth's surface, is the Harlot, also seized and bound by two Angels with chains, while her palaces are failing into ruins, and her counsellors and warriors are descending into the abyss, in wailing and despair.

Hell opens beneath the harlot's seat on the left hand, into which the wicked are descending.

* The painting, painted in 1808 and exhibited in 1809, has been lost, but preparatory versions survive, including one illustrated overleaf

The right hand of the design is appropriated to the Resurrection of the Just: the left hand of the design is appropriated to the Resurrection and Fall of the Wicked.

Immediately before the Throne of Christ are Adam and Eve, kneeling in humiliation, as representatives of the whole human race; Abraham and Moses kneel on each side beneath them; from the cloud on which Eye kneels, and beneath Moses, and from the tables of stone which utter lightning, is seen Satan wound round by the Serpent, and falling head-long; the Pharisees appear on the left hand pleading their own righteousness before the Throne of Christ: The Book of Death is opened on clouds by two Angels; many groups of figures are falling from before the throne, and from the sea of fire, which flows before the steps of the throne; on which are seen the seven Lamps of the Almighty, burning before the throne. Many figures chained and bound together fall through the air, and some are scourged by Spirits with flames of fire into the abyss of Hell, which opens to receive them beneath, on the left hand of the harlot's seat; where others are howling and descending into the flames, and in the act of dragging each other into Hell, and of contending in fighting with each other on the brink of perdition.

Opposite: A Vision of the Last Judgment, 1808

Before the Throne of Christ on the right hand, the Just, in humiliation and in exultation, rise through the air, with their Children and Families; some of whom are bowing before the Book of Life, which is opened by two Angels on clouds: many groups arise with exultation; among them is a figure crowned with stars, and the moon beneath her feet, with six infants around her, she represents the Christian Church. The green hills appear beneath; with the graves of the blessed, which are seen bursting with their births of immortality; parents and children embrace and arise together, and in exulting attitudes tell each others that the New Jerusalem is ready to descend upon earth; they arise upon the air rejoicing; others newly awaked from the grave, stand upon the earth embracing and shouting to the Lamb, who cometh in the clouds with power and great glory.

The whole upper part of the design is a view of Heaven opened; around the Throne of Christ, four living creatures filled with eyes, attended by seven Angels with seven vials of the wrath of God, and above these seven Angels with the seven trumpets compose the cloud, which by its rolling away displays the opening seats of the Blessed, on the right and the left of which are seen the four-and-twenty Elders seated on thrones to judge the dead.

Behind the seat and Throne of Christ appears

the Tabernacle with its veil opened, the Candlestick on the right, the Table with Show-bread on the left, and in the midst, the Cross in place of the Ark, with the two Cherubim bowing over it.

On the right-hand of the Throne of Christ is Baptism, on his left is the Lord's Supper—the two introducers into Eternal Life. Women with infants approach the figure of an aged Apostle, which represents Baptism; and on the left hand the Lord's Supper is administered by Angels, from the hands of another aged Apostle; these kneel on each side of the Throne, which is surrounded by a glory: in the glory many infants appear, representing Eternal Creation flowing from the Divine Humanity in Jesus; who opens the Scroll of Judgment upon his knees before the living and the dead.

Such is the design which you, my dear Sir, have been the cause of my producing, and which, but for you, might have slept till the Last Judgment.

William Blake.
January 18, 1808.

Blake and his wife were known to have lived so happily together, that they might unquestionably have been registered at Dumnow. 'Their hopes and fears were to each other known,' and their days and nights were passed in each other's company, for he always

painted, drew, engraved and studied, in the same room where they grilled, boiled, stewed, and slept; and so steadfastly attentive was he to his beloved tasks, that for the space of two years he had never once been out of his house ; and his application was often so incessant, that in the middle of the night, he would, after thinking deeply upon a particular subject, leap from his bed and write for two hours or more; and for many years, he made a constant practice of lighting the fire, and putting on the kettle for breakfast before his Kate awoke.

During his last illness, which was occasioned by the gall mixing with his blood, he was frequently bolstered-up in his bed to complete his drawings, for his intended illustration of Dante; an author so great a favourite with him, that though he agreed with Fuseli and Flaxman, in thinking Gary's translation superior to all others, yet, at the age of sixty-three years, he learned the Italian language purposely to enjoy Dante in the highest possible way. For this intended work, he produced seven engraved plates of an imperial quarto size, and nearly one hundred finished drawings of a size considerably larger; which will do equal justice to his wonderful mind, and the liberal heart of their

Opposite: Antæus setting Dante and Virgil down in the last circle of Hell, from illustrations to The Divine Comedy, *1824-7*

HELL Canto 31

possessor, who engaged him upon so delightful a task at a time when few persons would venture to give him employment, and whose kindness softened, for the remainder of his life, his lingering bodily sufferings, which he was seen to support with the most Christian fortitude.

On the day of his death, August 12th,*1897, he composed and uttered songs to his Maker so sweetly to the ear of his Catherine, that when she stood to hear him, he, looking upon her most affectionately, said, 'My beloved, they are not mine—no—they are not mine.' He expired at six in the evening, with the most cheerful serenity. Some short time before his death, Mrs. Blake asked him where he would like to be buried, and whether he would have the Dissenting Minister, or the Clergyman of the Church of England, to read the service: his answers were, that as far as his own feelings were concerned, they might bury him where she pleased, adding, that as his father, mother, aunt, and brother, were buried in Bunhill Row, perhaps it would be better to lie there, but as to service, he should wish for that of the Church of England.

His hearse was followed by two mourning-coaches,

* Not the 13th, as has been stated by several editors who have noticed his death.

attended by private friends: Calvert, Richmond, Tatham, and his brother, promising young artists, to whom he had given instructions in the Arts, were of the number. Tatham, ill as he was, travelled ninety miles to attend the funeral of one for whom, next to his own family, he held the highest esteem. Blake died in his sixty-ninth year, in the back-room of the first-floor of No. 3 Fountain-court, Strand, and was buried in Bunhill Fields, on the 17th of August, at the distance of about twenty-five feet from the north wall, numbered eighty.

Limited as Blake was in his pecuniary circumstances, his beloved Kate survives him dear of even a sixpenny debt; and in the fullest belief that the remainder of her days will be rendered tolerable by the sale of the few copies of her husband's works, which she will dispose of at the original price of publication; in order to enable the collector to add to the weight of his book-shelves, without being solicited to purchase, out of compassion, those specimens of her husband's talents which they ought to possess.

Extract from 'A Book for a Rainy Day'

[1784].—This year Mr. Flaxman, who then lived in Wardour Street, introduced me to one of his early

patrons, the Rev. Henry Mathew, of Percy Chapel, Charlotte Street, which was built for him; he was also afternoon preacher at Saint Martin's-in-the-Fields. At that gentleman's house, in Rathbone Place, I became acquainted with Mrs. Mathew and her son. At that lady's most agreeable conversaziones I first met the late William Blake, the artist, to whom she and Mr. Flaxman had been truly kind. There I have often heard him read and sing several of his poems. He was listened to by the company with profound silence, and allowed by most of the visitors to possess original and extraordinary merit.

* A time will come when the numerous, though now very rare works of Blake (in consequence of his taking very few impressions from the plates before they were rubbed out to enable him to use them for other subjects), will be sought after with the most intense avidity. He was considered by Stothard and Flaxman (and will be by those of congenial minds, if we can reasonably expect such again) with their highest admiration. These artists allowed him their utmost unqualified praise, and were ever anxious to recommend him and his productions to the patrons of the Arts; but, alas! they were not sufficiently appreciated as to enable Blake, as every one could wish, to provide an independence for his surviving partner, Kate, who adored his memory.

ALEXANDER GILCHRIST

Preliminary to
The Life of William Blake
'Pictor Ignotus'

1863

From nearly all collections or beauties of 'The English Poets,' catholic to demerit as these are, tender of the expired and expiring reputations, one name has been hitherto perseveringly exiled. Encyclopædias ignore it. The Biographical Dictionaries furtively pass it on with inaccurate despatch, as having had some connexion with the Arts. With critics it has had but little better fortune. The *Edinburgh Review*, twenty-seven years ago, specified as a characteristic sin of 'partiality' in Allan Cunningham's pleasant *Lives of British Artists*, that he should have ventured to include this name, since its possessor could (it seems) 'scarcely be considered a painter' at all. And later, Mr Leslie, in his *Handbook for Young Painters*, dwells on it with imperfect sympathy for awhile, to dismiss it with scanty recognition.

Yet no less a contemporary than Wordsworth, a man little prone to lavish eulogy or attention on brother poets, spake in private of the *Songs of Innocence and Experience* of William Blake, as 'undoubtedly the production of insane genius,' (which adjective we shall, I hope, see cause to qualify), but as to him more significant than the works of many a famous poet.

Opposite: Frontispiece to America, a Prophecy, *written in 1793. This is from a copy printed in 1821 and bought in that year by the painter John Linnell*

'There is something in the madness of this man,' declared he (to Mr Crabb Robinson), 'which interests me more than the sanity of Lord Byron and Walter Scott.'

Of his *Designs*, Fuseli and Flaxman, men not to be imposed on in such matters, but themselves sensitive – as Original Genius must always be – to Original Genius in others, were in the habit of declaring with unwonted emphasis, that 'the time would come' when the finest 'would be as much sought after and treasured in the portfolios' of men discerning in art, 'as those of Michael Angelo now.' 'And ah! Sir,' Flaxman would sometimes add, to an admirer of the designs, 'his poems are grand as his pictures.'

Of the books and designs of Blake, the world may well be ignorant. For in an age rigorous in its requirement of publicity, these were, in the most literal sense of the words, *never published* at all: not published even in the mediæval sense, when writings were confided to learned keeping, and works of art not unseldom restricted to cloister-wall or coffer-lid. Blake's poems were, with one exception, not even printed in

Opposite: Watercolour illustration for preliminary page to 'Ode on the Death of a Favourite Cat, drowned in a Tub of Gold Fishes,' 1797-8, part of a collection of poems by Thomas Gray which Blake was commissioned to illustrate by John Flaxman. The volume later belonged to the collector William Beckford

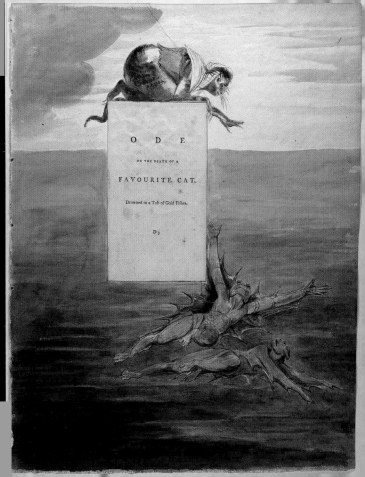

O D E

ON THE DEATH OF A

FAVOURITE CAT.

Drowned in a Tub of Gold Fishes.

D 3

his life-time; simply *engraved* by his own laborious hand. His drawings, when they issued further than his own desk, were bought as a kind of charity, to be stowed away again in rarely opened portfolios. The very copper-plates on which he engraved were often used again after a few impressions had been struck off; one design making way for another, to save the cost of new copper. At the present moment, Blake drawings, Blake prints, fetch prices which would have solaced a life of penury, had their producer received them. They are thus collected, chiefly because they *are* (naturally enough) already 'RARE,' and 'VERY RARE.' Still hiding in private portfolios, his drawings are there prized or known by perhaps a score of individuals, enthusiastic appreciators, – some of their singularity and rarity, a few of their intrinsic quality.

At the Manchester Art-Treasures Exhibition of 1857, among the select thousand water-colour drawings, hung two modestly tinted designs by Blake, of few inches size: one the *Dream of Queen Catherine*,[1] another *Oberon and Titania*.[2] Both are remarkable displays of imaginative power, and finished examples in the

1. Fitzwilliam Museum, Cambridge. 2. Private collection

Opposite: Dream of Queen Catherine, c. 1825, similar in composition to the painting exhibited in 1857

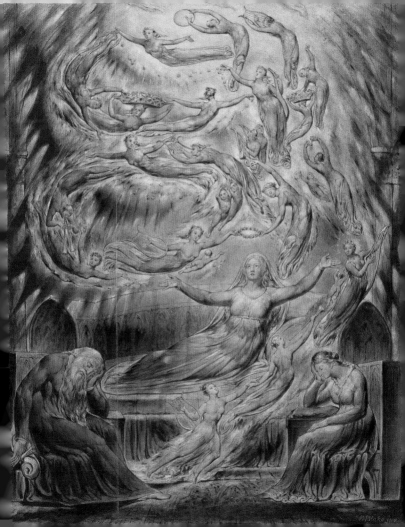

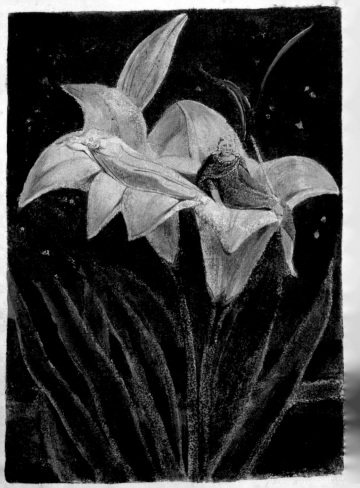

artist's peculiar manner. Both were unnoticed in the crowd, attracting few gazers, fewer admirers. For it needs to be *read* in Blake, to have familiarized oneself with his unsophisticated, archaic, yet spiritual 'manner,'—a style *sui generis* as no other artist's ever was,—to be able to sympathize with, or even understand, the equally individual strain of thought, of which it is the vehicle. And one almost must be *born* with a sympathy for it. He neither wrote nor drew for the many, hardly for work'y-day men at all, rather for children and angels; himself a 'divine child,' whose playthings were sun, moon, and stars, the heavens and the earth.

In an era of academies, associations, and combined efforts, we have in him a solitary, self-taught, and as an artist, *semi*-taught Dreamer, 'delivering the burning messages of prophecy by the stammering lips of infancy,' as Mr. Ruskin has said of Cimabue and Giotto. For each artist and writer has, in the course of his training, to approve in his own person the

Opposite: Oberon and Titania, from The Song of Los, written and printed in 1795. This is the same composition as the painting exhibited in 1857, which is approximately the date at which Benjamin Disraeli probably bought this copy

Overleaf: The Night of Enitharmon's Joy, designed and printed in 1795. This sheet was bought by the critic and social reformer John Ruskin, but shortly afterwards returned to the dealer

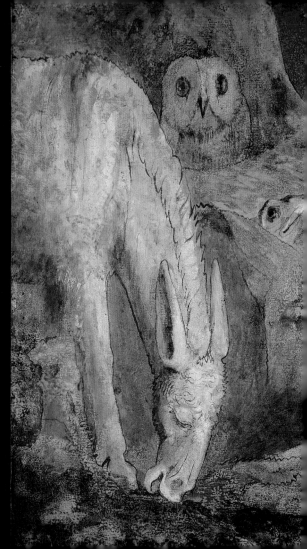

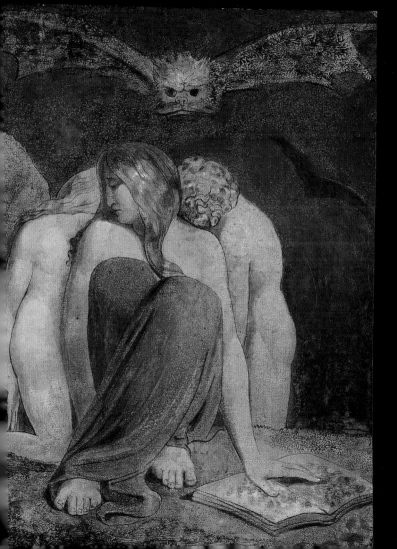

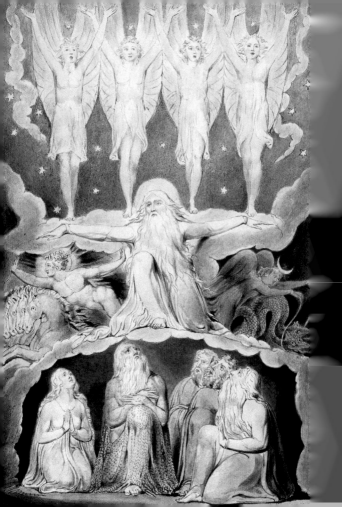

immaturity of expression Art has at recurrent periods to pass through as a whole. And Blake in some aspects of his art never emerged from infancy. His Drawing, often correct, almost always powerful, the *pose* and grouping of his figures often expressive and sublime, as the sketches of Raffaelle or Albert Dürer, often, on the other hand, range under the category of the 'impossible'; are crude, contorted, forced, monstrous, though none the less efficient in conveying the visions fetched by the guileless man from heaven, from hell itself, or from the intermediate limbo tenanted by hybrid nightmares. His prismatic colour, abounding in the purest, sweetest melodies to the eye, and always expressing a sentiment, yet, looks to the casual observer slight, inartificial, arbitrary.

Many a cultivated spectator will turn away from all this, as from mere ineffectualness,—Art in its second childhood. But see this sitting figure of *Job in his Affliction*, surrounded by the bowed figures of wife and friend, grand as Michael Angelo, nay, rather as the still, colossal figures fashioned by the genius of old Egypt or Assyria. Look on that simple composition of *Angels Singing aloud for Joy*, pure and tender as Fra

Overleaf: When the Morning Stars Sang Together, 1804-7, from the watercolour illustrations to the Book of Job commissioned for Thomas Butts

Angelico, and with an austerer sweetness.

It is not the least of Blake's peculiarities, that instead of expressing himself, as most men have been content to do, by help of the prevailing style of his day, he, in this, as every other matter, preferred to be independent of his fellows; partly by choice, partly from the necessities of imperfect education as a painter. His Design has conventions of its own; in part, its own, I should say, in part, a return to those of earlier and simpler times.

Of Blake, as an Artist, we will defer further talk. His Design can ill be translated into words, and very inadequately by any engraver's copy. His Poems, tinged with the very same ineffable qualities, obstructed by the same technical flaws and impediments, are as it were a semi-utterance snatched from the depths of the vague and unspeakable. Both form part in a Life and Character as new, romantic, pious – in the deepest natural sense – as they: romantic, though incident be slight; animated by the same unbroken simplicity, the same high unity of sentiment.

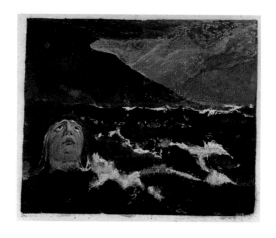

Part of plate 24 of the First Book of Urizen, *1794*
as reprinted in A Small Book of Designs,
made for the painter Ozias Humphry in 1796

List of illustrations

Unless otherwise indicated, all works are colour-printed relief etchings on paper with added watercolour

188